IMAGES
of America

RUTLAND

IMAGES
of America
RUTLAND

Bernice May Anderson

ARCADIA

First printed in 2000.

Published by Arcadia Publishing,
an imprint of Tempus Publishing, Inc.
2 Cumberland Street
Charleston, SC 29401

Printed in Great Britain.

Library of Congress Catalog Card Number: applied for.

For all general information contact Arcadia Publishing at:
Telephone 843-853-2070
Fax 843-853-0044
E-Mail sales@arcadiapublishing.com

For customer service and orders:
Toll-Free 1-888-313-2665

Visit us on the internet at http://www.arcadiapublishing.com

This book is dedicated to my husband, Ralph, and to my children, Kathy and Todd, who have always made my life an adventure.

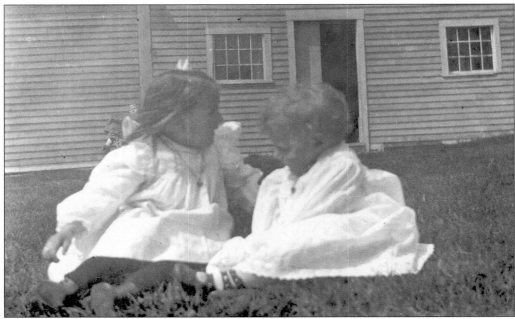

Shown are two Rutland children at the turn of the century.

CONTENTS

Introduction 7

1. Along Main Street 9

2. West Rutland 41

3. North Rutland and Rutland Youngsters 59

4. Businesses 71

5. Train Service 75

6. Hospitals and Sanatoriums 81

7. Tornado 97

8. Things to Do 105

Acknowledgments 128

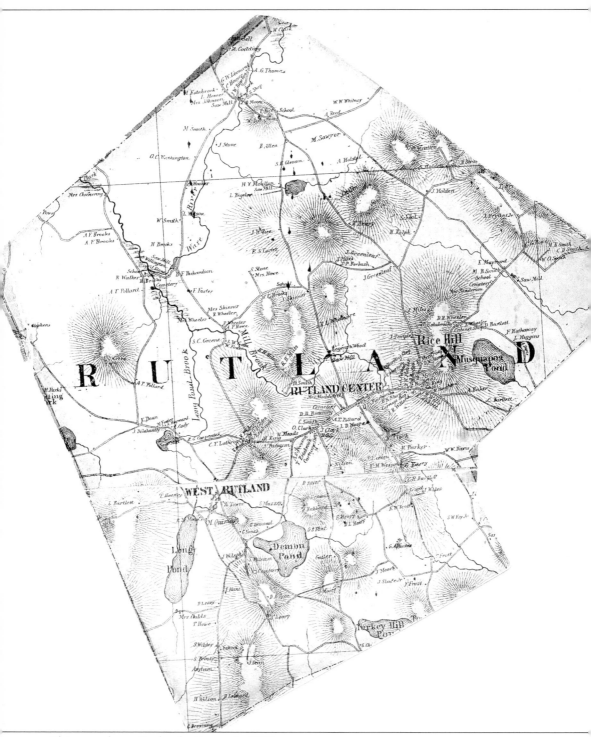

This map shows Rutland as it was in 1870.

INTRODUCTION

Rutland sits quietly nestled among the hills of central Massachusetts, 10 miles from Worcester, Massachusetts. The Main Street, from Glenwood Road to the Barrack Hill site, reflects almost completely the late 1800s. It is the last of the village areas that remains intact. A few ranch-style homes dot Main Street before the center as you enter the town from Holden. These structures bear witness to the path taken by the 1953 tornado that plowed through Rutland. Pockets of housing developments nestle here and there and small businesses dot the area. The development of the Quabbin water supply by the Metropolitan District Commission (MDC) took over other village areas in Rutland. The forests and parks of the MDC lands blanket the areas that were once West Rutland Village and North Rutland.

Rutland's history is as old as the country, and the town has been part of it all. In 1686, just 66 years after the Pilgrims landed in Plymouth, the lands that became Rutland were bought from the native people. An area of 12 square miles (93,160 acres) was bought for 23 pounds in English money, which equals about 80¢ per square acre. It was finally registered in court in 1713 and surveyed in 1715. In 1716, settlers came to this wilderness to cut out a settlement and build homes for their families.

Native American raids, forts, maypoles, stocks, militia drilling on the Common, Redcoats and Hessian Dragoons, and Shay's Regulators all graced the pages of our early history. The 1800s saw industry abound and the villages develop. The Civil War tore our young men from their homes to fight to preserve what their fathers had won. Throughout, we remained an agrarian township.

The late 1800s brought Rutland to her age as a health care and summer resort town. The state sanatorium for tuberculosis was built and private sanatoriums sprang up all over town. Hotels flourished and the State Prison Camp and Hospital was built on wild forestland. With it came the railroad and a public water supply. Electricity came in 1914.

The building of the Veterans Administration Hospital brought sewer lines to Rutland and extended the water lines. World War I and World War II broke out, and the availability of the automobile allowed more people to work in the city of Worcester; farming decreased in Rutland. The railroad was gone by 1938, along with the hotels and prison camp. By the 1940s, the town had its first housing developments. The Rutland State Sanatorium closed in 1965. Rutland lost her last hospital in 1991, when the Rutland Heights Hospital was closed. Throughout, only housing development has increased in Rutland. Now, the town is considered a bedroom community to Worcester.

Historical research is like unraveling a mystery. Much is written, but it must be found, checked, and analyzed with an eye for the social and political attitudes of that day and place. Histories often conflict with each other, and "like the history of the American Indian, it is often written by the enemy," to quote from *The History of Shays Rebellion*. We have used information for this work from many sources without any attempt to prove or disprove this information. Paintings, woodcuts, postcards, and photographs give us a pictorial link to the past, with details not possible in other media. Newspaper clippings are an invaluable source for any research as are private newsletters and correspondence. Books and booklets used for information in this work are as follows:

CF Jewitt & Co. *History of Worcester County.*Boston, Mass.: Wright & Potter Printing Co., 1879.
Dufault, Paul. *Rutland State Sanatorium.* Worcester County Health Association, 1964.
Hurd, D. Hamilton. *History of Worcester County.* Philadelphia, Pa.: J.L. Lewis & Co., 1889.
Murphy, Timothy. *History of Rutland.* Worcester, Mass.: Rutland Historical Society, 1970.
Nelson, John. *Worcester County.* American Historical Society Inc., 1934.
Reed, Jonas. *History of Rutland.* Worcester, Mass.: Mirick & Bartlett Printers, 1836.
Rutland Fire Brigade. *Picturesque Rutland.* Worcester, Mass.: E.H. Tripp, 1904.
Tercentenary Committee. *Tercentenary Booklet.* Worcester, Mass.: Prouty Printing Co., 1930.
Two hundred fiftieth Anniversary Committee. *250th Souvenir Booklet.* 1972.
Two hundred seventy-fifth Anniversary Committee. *Rutland's 275th Anniversary Booklet.* 1997.

At this junction in our history, we sit at the cornerstone of a new global world as uncertain, apprehensive, and exciting as when the forefathers of this nation ventured into this wilderness. May the photographic images of tomorrow show peace as we forge on.

One

ALONG MAIN STREET

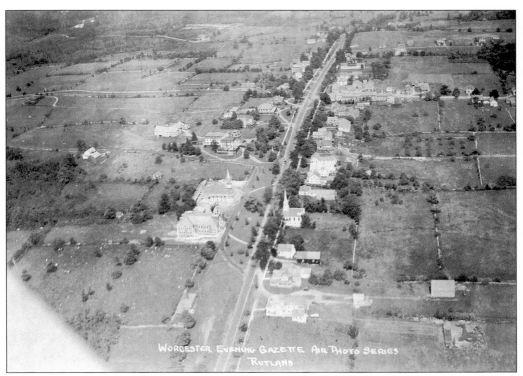

Although many of the original houses on the right side of the road remain, many on the left have been razed. This early-1900s image of Rutland Center shows the Methodist church across from the Common, on the right side of the road, and the Jewish Sanatorium, where Naquag Elementary School now sits. On the left side of the road, the old red brick school house sits next to the Congregational church. The toboggan run from the second floor of the Bartlett Hotel can be seen extending to the pine trees.

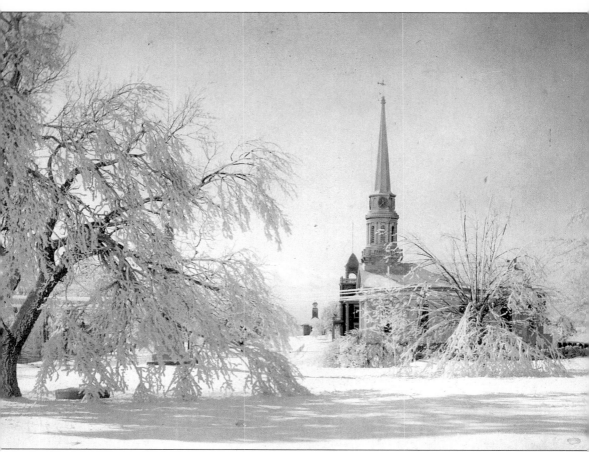

This winter scene shows the First Congregational church before it burned on November 13, 1926. The church was established in 1720 as the First Church of Christ and was built the following year at the corner lot by the cemetery. A meeting house was built in front of it, and the original church building was sold to John Murray, who moved it. The original building on the new site was built in 1759. It was lost to fire in 1830 and was rebuilt. It burned in 1926 and was again rebuilt.

This picture also shows the old Red School House and the Old Fire Barn when it was a one-story building with the bell tower. A second story was added in 1933 as a National Recovery Act (NRA) project. Plane spotters in WWII used the building. The Old Fire Barn is now leased by the Rutland Fire Brigade.

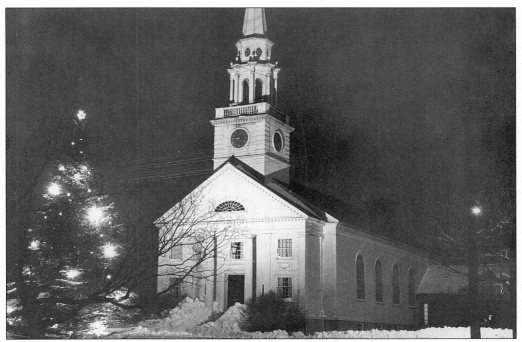

The spruce shown was planted in 1930 as part of the town's tercentenary celebration of the Massachusetts Bay Colonies. It stands in front of the First Congregational church.

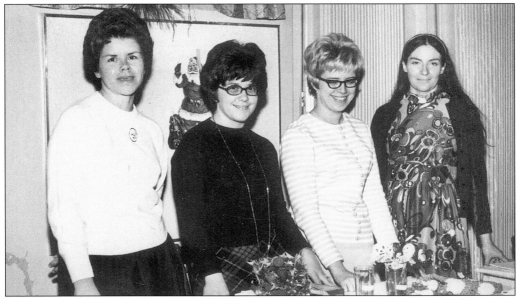

The First Congregational Church has been part of the community almost from the town's beginning, and the Christmas fairs have been a continuing part of the church's activities. Virginia Lamoureau, Carolyn Root, Ann Davis, and Jackie Taylor are all set for the Tinsel Time Fair in 1970. (Photograph by Eugene Kennedy.)

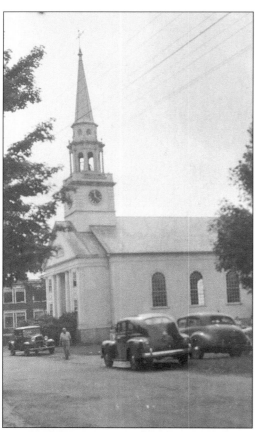

These 1940s are lined up for the First Congregational Church outing and fair.

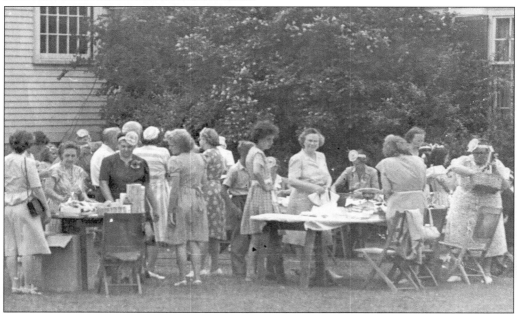

This outside event at the First Congregational church was well attended.

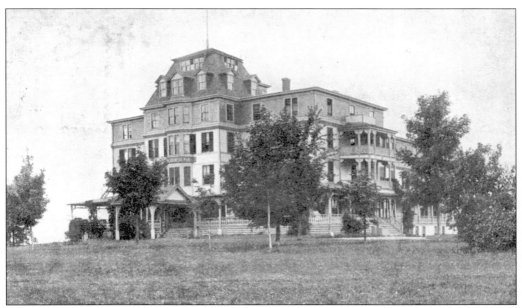

Seen here in 1907, the Muschopauge House (then the Bartlett Hotel) was a 100-room grand hotel that attracted many summer visitors. It was built in 1883 and was open for guests until 1929, when the town bought and razed it. It was built by C.W. Bartlett and L.Q. Spaulding

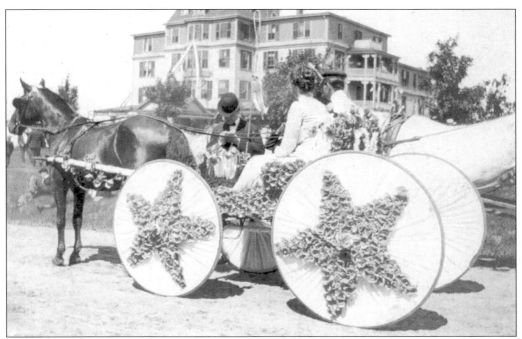

Guests and townspeople enjoyed the Coaching Parades from the Muschopauge Hotel during the 1900s. Horses and wagons were the "coaches" of this period.

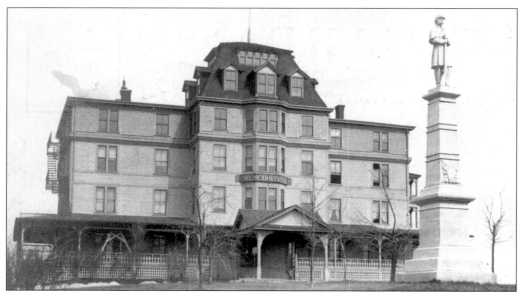

The Civil War monument in front of the hotel was dedicated on July 3, 1879. A total of 54 men enlisted from Rutland. The first two to enlist were Isaac Parker and Oliver Judkins; the last to enlist was Joshua Roberts. The money for it was raised by returned Civil War soldiers with the help of townspeople. The monument was made of Pittsford, Vermont marble by Murphy & Magone, Boston Marble Works, Worcester. It was 22 feet high and 5 feet square at the base. The full-sized soldier on top was toppled and destroyed during the 1938 hurricane and replaced in 1983 by the Rutland Historical Society. The replacement was commissioned to Worcester Monumental Works and was made in Italy from Carrara marble. The figure stands at parade rest and faces south, with the names of 82 soldiers engraved on the base.

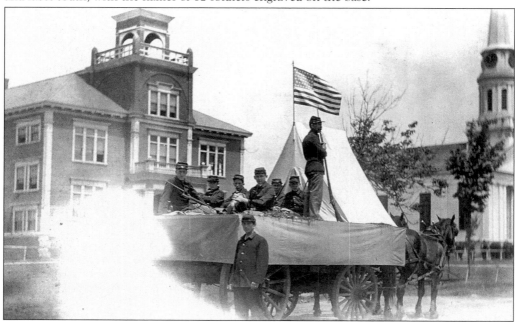

The Civil War soldier was the theme for this 1914 entry in the Old Home Day parade.

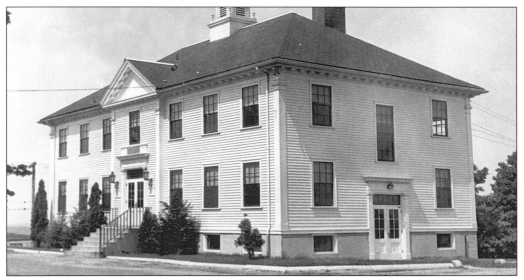

Community Hall, built 1939, was designed by one of Charles Bartlett's sons. It was built on the site of the Bartlett Hotel, the former Muschopauge Hotel, when the town bought it in 1929. It still serves as Rutland's government offices. (Photograph by Albert Thomas.)

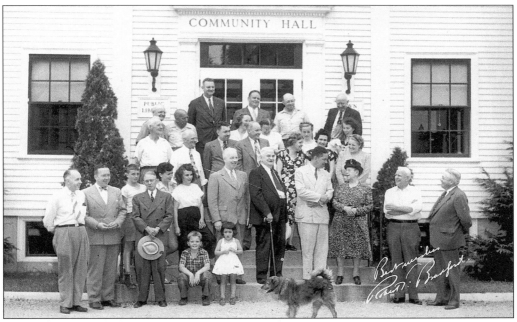

The dedication of Community Hall in 1939 was a grand celebration. Here, some of the dignitaries pose with Governor Bradford. From left to right, they are as follows: (first row) John Linnane, Albert Thomas, Clint Putnam, unidentified, Frank Brooks, Charles Carroll, Governor Bradford, Frances Hanff, Bill Read, and unidentified; (second row) Bill White, Dexter Marsh, Charlotte Judkins, unidentified, Alma Holbrook, and unidentified; (third row) Robert Culver, unidentified, Clarence Bigelow, and Lloyd Prescott; (fourth row) Fred Kehoe, Edgar Faye, Rev Bickett, Jack Collins, Marjorie Thomas, unidentified, and Marion Fay.

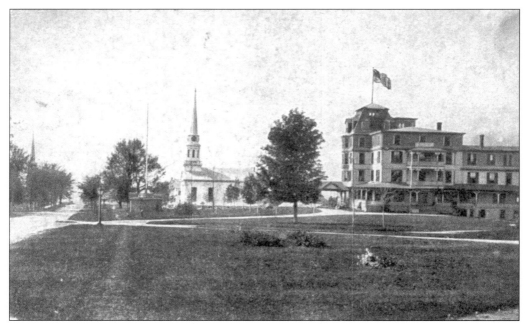

In this photograph, you can see the open bandstand where music often filled the air in front of the Muschopauge Hotel. The bandstand did not have a top. The First Congregational church stands in the center, and the steeple of the Methodist church can be seen across the roadway.

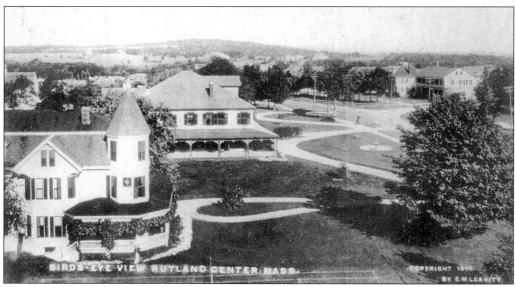

This view shows the town center from the Spaulding House, which stood beside the Bartlett Hotel. The Prospect House, located where the fire station now stands, can be seen in the center of the picture.

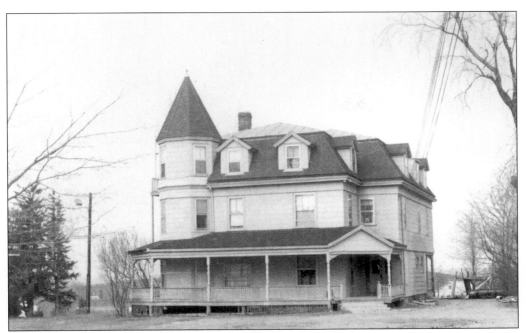

The Spaulding House was built by L.Q. Spaulding and stood next to the Bartlett Hotel. It was connected by a walkway and accommodated guests in the summer.

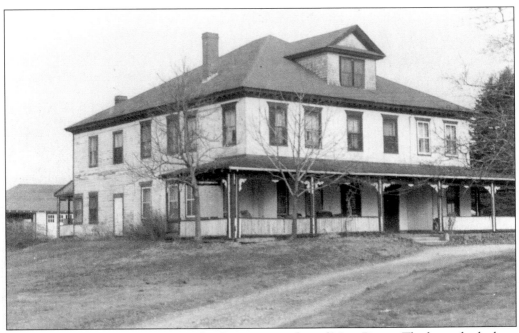

In 1904, the Prospect House was under the proprietorship of Mary Pierce. The house had a long history as a hotel and rooming house. It was in direct line with the Muschopauge Hotel and the Spaulding House. It stood on the site of the present-day fire station.

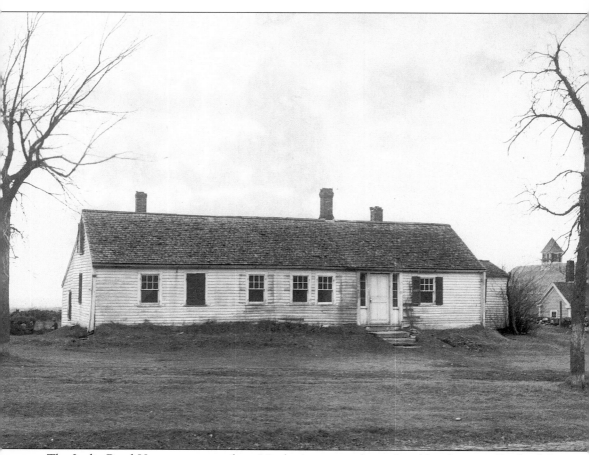

The Lydia Reed House sat across from Maple Avenue and was the oldest house in Rutland. It was razed sometime after Reed's death in 1904. An undated article states, "Rutland from its birth as a village got along without anything resembling fire fighting apparatus until a small barn and shed owned by Miss Lydia W. Read, who was known generally in the town as 'Aunt Lydia' were destroyed by fire. This was in 1889. This fire was in the center village and Edmund Muzzy, Benjamin Browning, Peter S. O'Connor and George Putnam decided it was time to have something to fight fires with. They built a ladder wagon and appropriated the basement of the town hall as a firehouse and the Rutland Fire department had its beginning."

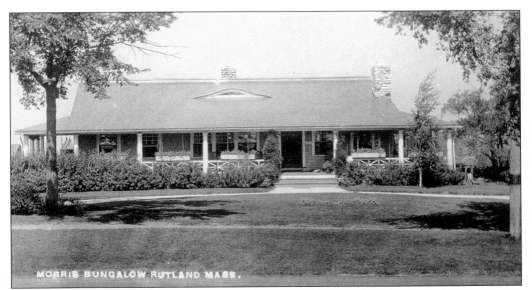

The Morris Bungalow now stands at 232 Main Street. It was built by Lewis and Sadie Morris, c. 1908. They had come to Rutland because Sadie had tuberculosis; she succumbed to the disease in 1919. Morris later married her nurse, Hazel Hanff. He died in 1925. Famed artist Franklin Wood married Mrs. Hazel Morris in 1938, and the bungalow became known as the Morris-Wood house. It is believed to have been built on the foundation of the Lydia Reed house that was built in 1788. Now known as the Wood house, the building serves as headquarters for the police department and the Rutland Historical Society.

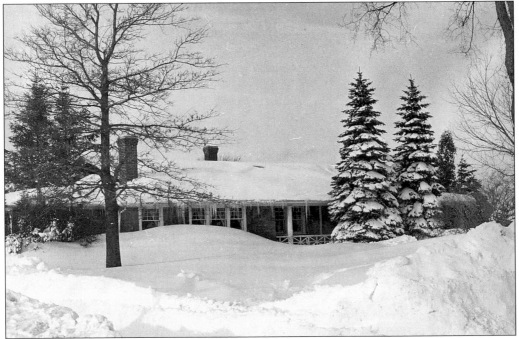

The Wood house, presently the police station, is blanketed by snow in this image. (Photograph by Albert Thomas.)

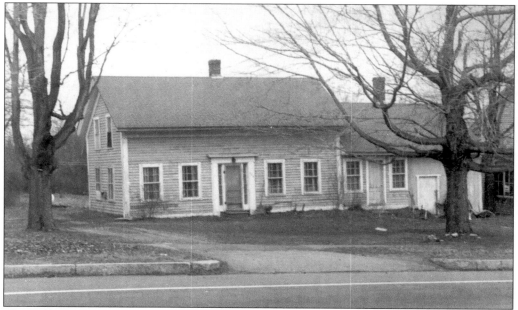

The Nellie Griffin house sat across the street from the store at the corner of Maple Avenue and Main Street. The house was torn down in the 1980s, and the site is now the roadway into Rolling Ridge Estates.

Descendants of the Putnam family and daughters to Walter and Terry Putnam, Ellen and Lisa Putnam lived in the Prospect House and later the Nellie Griffin house.

20

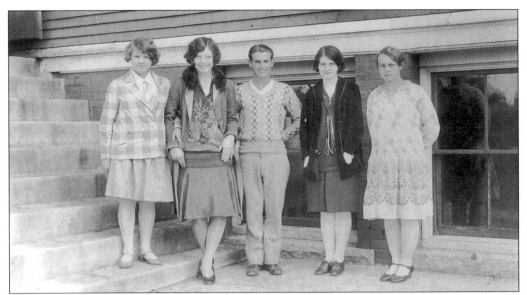

Shown is the Rutland High School Class of 1928. The members, from left to right, are as follows: Greta (Wendt) Taft, Doris (Prescott) Maclean, George Albert Bryant Jr., Grace (Carroll) Wood, and E. Viola (Bigelow) Fairbanks.

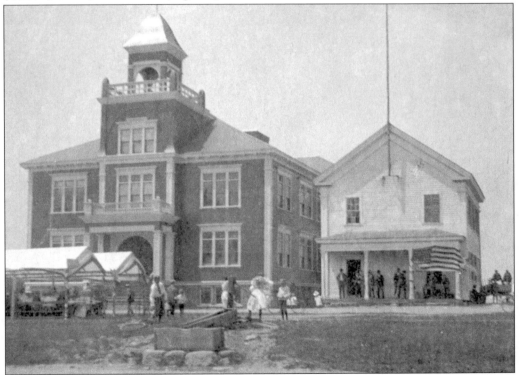

The building that became known as Rutland High School was built as a town hall, a free public library, and a school. It was dedicated in 1899 and served as a high school until 1954. Next to it is the old town hall, which was moved down Main Street and became the Masonic Hall.

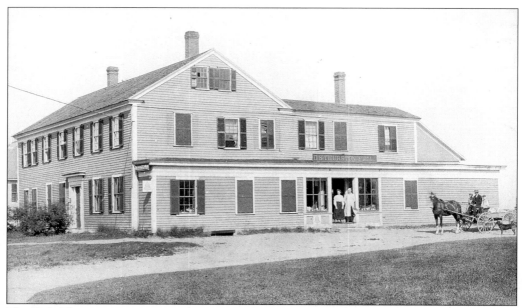

The D.S. Thurston store was on the corner of Main Street and Maple Avenue. It later became the Nellie Griffin General Store. John Collins was the last owner to run a general store at this location. He had worked for Nellie Griffin before taking ownership of the building in 1916. He ran it as an old country store until 1966, when he retired. He worked as the Rutland police chief until 1971. It now houses apartments and Rutland Pizza.

The corner of Maple and Main Street has always been a hub of business, as this 1948 photograph shows. Note that the roadway is level with the buildings. Today, the buildings and businesses in this area all sit above the road. (Photograph by Albert Thomas.)

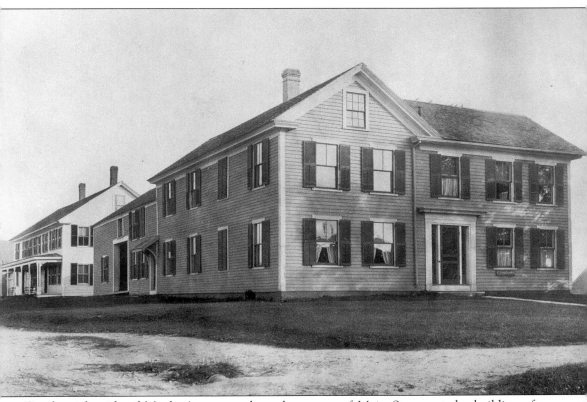

On the right side of Maple Avenue and on the corner of Main Street sat the building of Dr. Chamberlain. It has served many purposes over the years and is now a business and an apartment building.

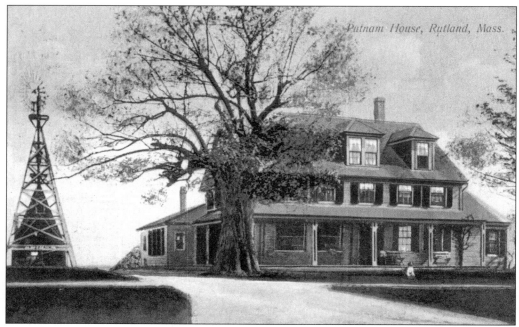

The Bracebridge House was built by Lt. Joseph Blake. Over the years, it was occupied by William Caldwell, lawyer Francis Blake, Squire George Flint, Franklin Hathaway, and in 1904 by Philena Putnam. The first public library was in the Bracebridge house and George A. Putnam, who resided there, was appointed the first librarian. This postcard from 1910 shows the windmill that was used to pump water.

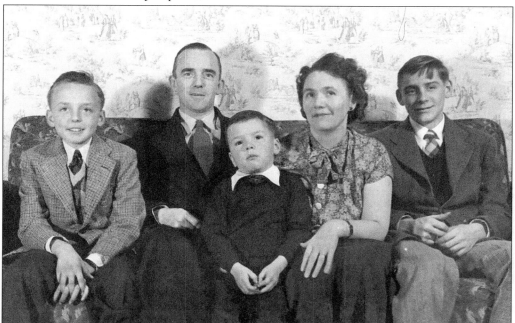

This 1948 picture of the Bracebridge family was taken by Albert Thomas. Family members, from left to right, are Jack, Frank, Eddy, Hope, and Charles Bracebridge.

The former home of Miles Holden, the charming Webber House sits in the center of town. Holden may be the man seen coming from the stable with the horse and buggy. The stable section now serves as an apartment. Holden made many changes to this early house that was built on Lot 4. Originally, Lot 4 had been given to Capt. Jacob Stevens when the town was formed. An undated article notes that "Miles Holden has sold his farm of 91 acres, known as Barrack Hill Farm, to Charles W. Gilbert of Worcester" before moving to the center.

This pillared house was leveled in 1999. It was listed as owned by Avaline Bigelow in 1904, a relative of the Honorable J. Warren Bigelow. It has housed many businesses over the years. The second floor once housed the switchboard system for Rutland telephone service. Mark Steritts and Jack Richards recently reconstructed the house to its exact façade, complete with pillars. It serves as a business building.

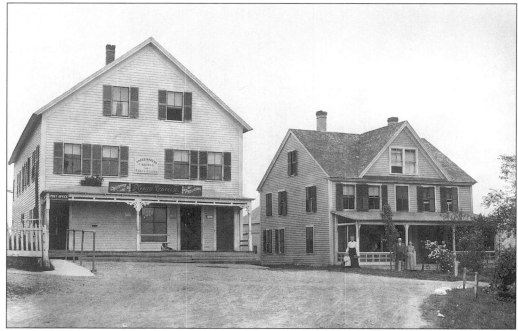

The building on the left has been a store for most of its history. It was run by Jonas Estabrook and Walter Forbes. In 1904, it was the home and business of Henry Converse, Rutland's first fire chief. Mary Converse was vice president of the Rutland Historical and Public Improvement Society in 1902. Lyman Forbes lived next-door in the Pratt house pictured on the right.

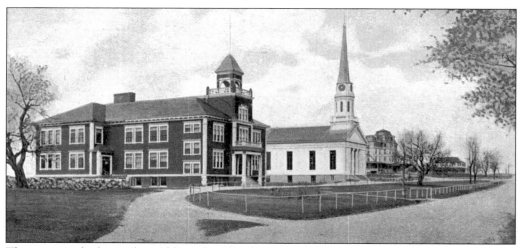

This postcard show the Old Red Schoolhouse, the First Congregational church, the Muschopauge Hotel, the Prospect House, and the fenced-in Common. The Common was laid out for the town at the same time as the Ten Rod Road.

Shown here in 1948, the Old Jewish Tubercular Sanatorium, an Italianate structure, was a nonsectarian institution, according to a 1950 article. It had a 25-bed capacity and 13 employees. In 1950, Alex Solomon was the resident doctor. It had originally been Mrs. Brown's Private Sanatorium. The sanatorium and residence building on the property was bought by the town and razed to build the present Naquag Elementary School at 285 Main Street. (Photograph by Albert Thomas.)

This residential building was part of the Jewish Sanatorium. It stood where the driveway to the school is today. (Photograph by Albert Thomas.)

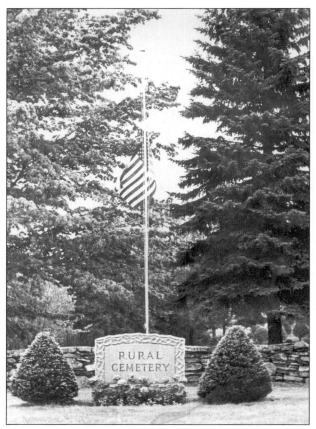

In 1842, the Rutland Rural Cemetery on Main Street was founded by Col. C.G. Howe in association with 16 others. It was designed by Daniel Wheeler. Today, it is privately owned. Erected in 1941, the chapel and fountain were given by Eleanor Rawson Green of New Rochelle, New York in memory of her parents, Oscar Rawson and H. Amelia Read. The monument bearing the cemetery's name and the flag pole were given by Harold T. Judkins and family in 1969. (Photograph by Wayne Myers.)

This old postcard shows the old Miles homestead at 156 Main Street, which was once a creamery. The smaller building was a garage brought up from the cemetery and converted to a home at 154 Main Street.

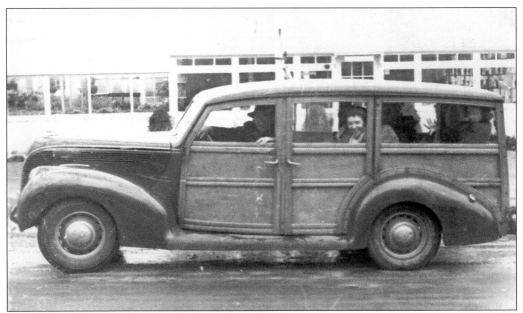

This 1938 station wagon belonging to Herbert Bigelow was always ready to go.

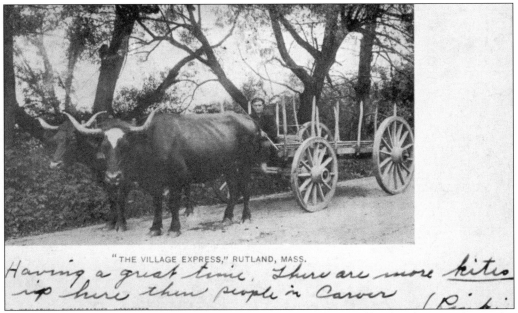

"THE VILLAGE EXPRESS," RUTLAND, MASS.

Having a great time. There are more kites up here than people in Carver (Ri...

This 1907 postcard shows another form of transportation, identified by the photographer as the "Village Express."

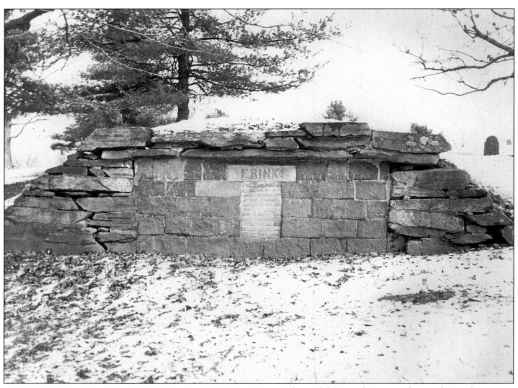

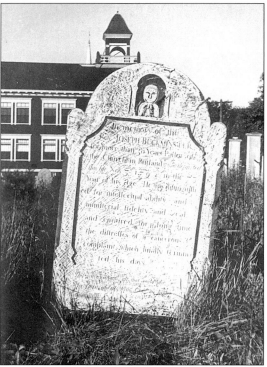

The Old Burial Ground stands in the center of town, near the Old Fire Barn opposite the Naguay Elementary School. It was laid out in 1743 and holds some of the best examples of early stone carvings. Carvings by William Young of Worcester abound here. The cemetery was used until 1842. Shown here is the Frink vault. (Photograph by Jeene Collins.)

This photograph of the Joseph Buckminster stone was taken by Albert Thomas in 1948. Reverend Buckminster served the town for 50 years, until his death in 1792.

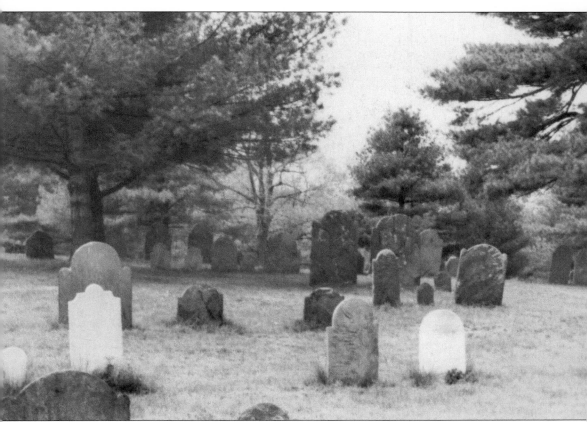

In the Old Burial Ground, by the Old Fire Barn on Main Street, one granite headstone reads, "Here lies buried ye body of Mr Daniel Campbell born in Scotland, came into New England *anno* 1716. Was murdered on his own farm in Rutland by Ed Fitzpatrick, an Irishman on March ye 8th 174 in the 48th year of his age. Man knoweth not his time." Ed Fitzpatrick was employed or indentured by Daniel Campbell on his farm in Rutland. The murder was the first in Worcester County and in Rutland. Fitzpatrick was indicted in Worcester on March 12, 1744. The warrant for his execution was issued on September 22, 1744. He was hanged in Lincoln Square on October 18, 1744, the first person in Worcester County to be hanged. The prosecutor was attorney general William Brattle and the judge was Paul Dudley. Foreman of the jury was Thomas Wheeler.

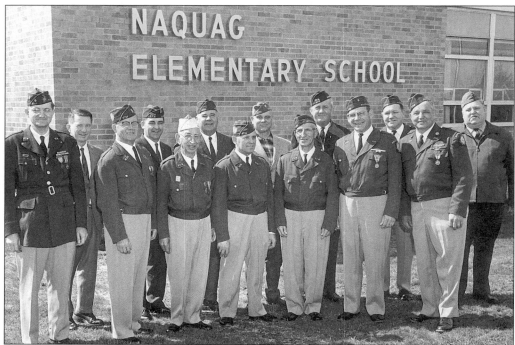

When the Naquag Elementary School was finished being built in 1966, the American Legion presented the letters to the school. Shown here, from left to right, are the following: (front row) Edward Turner, Daniel T. Connor, Joseph H Leslie Sr., William W. Suchocki, Henry I. Leslie, Veikko A. Jarvi, and Andrew Kolofsky; (back row) Bert Eaton, Arthur D. McNutt, Stanley P. Ericson, Arne E. Hagman, Frederick L. Davis, Attilio C. Alinovi, and Raymond E. Miller. (Photograph by Casson-Foster.)

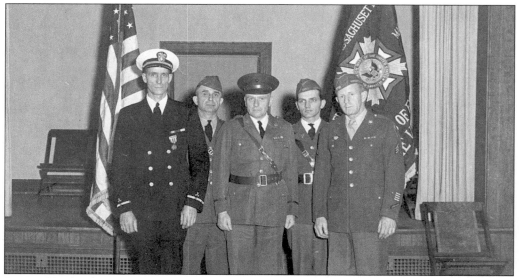

Some of Rutland's returning servicemen can be seen in this 1948 photograph of the Veterans of Foreign Wars Installation. They are, from left to right, John Yonkers, Andy Kolofsky, Frank Hayden, Stanley Erickson, and unidentified. (Photograph by Albert Thomas.)

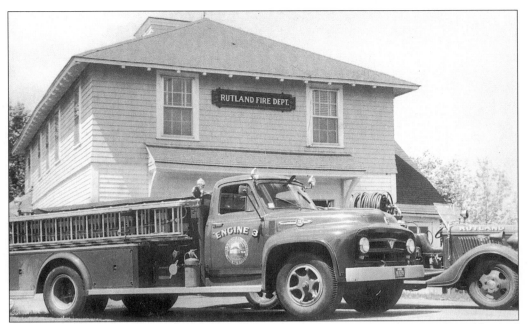

The Rutland Fire Brigade restored the Old Fire Barn in 1998. It stands next to the Old Burial Ground on Main Street. The second story was added in 1933 as an NRA project. The first story was built in 1897 as a hose house and stands on the site of the first meetinghouse.

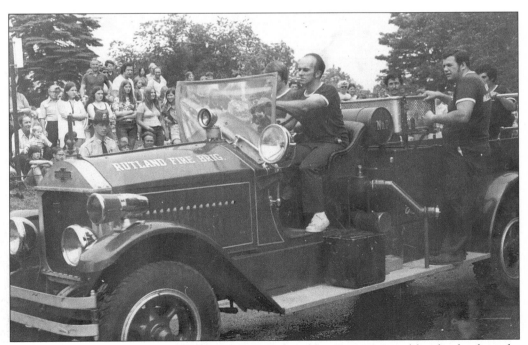

A favorite entry for parade and muster events is the old LeFrance owned by the fire brigade. Shown during some 1972 celebration events, Keith Whitcher drives, while Henry Ruchala and Gary Liimatainen are on back

These old firefighters are, from left to right, as follows: (front row) Howard Davis, Fred Kehoe, Frank Smith, Ed Fay, Clarence Oliver, Miles Griffin, and John Wiback; (back row) John Coffin, William White, Frank Mathews, Les Prescott, George Smith, and Pat Myers.

In 1894, Henry Converse was selected to be among Rutland's first firefighters. He served until his death in 1919 at age 83. Captain Converse lived opposite the Common, where he ran a general store and the post office. The pump house was within sight of his home.

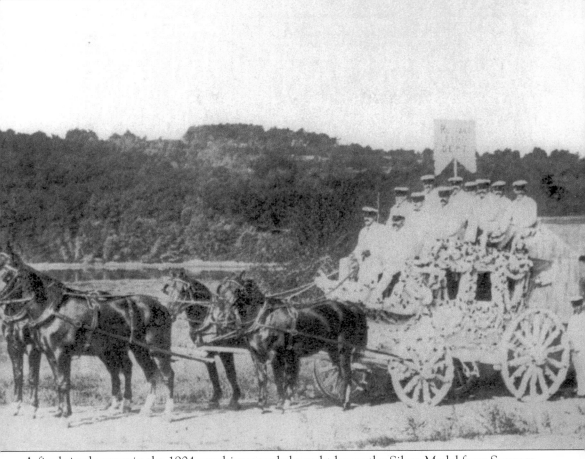

A fire brigade entry in the 1904 coaching parade brought home the Silver Medal from Spencer that year. Pictured, from left to right, are the following: (Rutland front seat) Joseph Hadley-Driver and Capt. Henry Converse; (Rutland second seat) Walter Reed, Clinton Putnam, and H. Edw. Wheeler. (Spencer front seat) Wm. M. Demond, Jas. Putnam, and Patrick Murphy; (Spencer rear seat) Louis Hanff, Henry Stone, and Charles Stone; (ground) Fred Tucker. The ladies who rode inside included Mrs. Henry Converse, Mrs. Patrick Murphy, Mrs. Louis Hanff, and Mrs. H. Edward Wheeler. (Courtesy of fire chief Thomas Ruchala.)

A new ambulance was approved in 1977 and was received in February 1978 from Richard Kaplan of the Miller-Media Ambulance Agency. Here, fire chief Thomas Ruchala (left) receives the keys from Richard Kaplan. (Photograph by Wayne Myers.)

Victoria Tarbell served for many years as a dispatcher for the Rutland Police and Fire Departments after she became blind. At that time, dispatchers worked from their homes covering 12-hour shifts. She never missed a call or forgot a number. Vickie resigned in 1979, but continued to dispatch for her church. Here, she receives an award from the Rutland American Legion Cmdr. Ed Turner (right) and Robert Zoppo (left).

Franklin T. Wood was a famous etcher who came to a relative's sanitarium in Rutland when he became ill. Already world renowned at 38 years of age in 1915, he was given two years to live by doctors. He proceeded to build a studio and living quarters at 57 Maple Avenue, adding on when his mother and relatives came to stay with him. He lived there until he married for the first time at age 61 in 1938. He married Hazel Hanff Morris and moved into what is now known as the Wood house at 232 Main Street. When Mrs. Wood's sister, Linda Hanff, was asked about her brother-in-law, she simply stated, "He was the artist type, you know." He is described as a tall, thin, private man with an artistic bearing. He died in 1945 and is buried in the Rutland Rural Cemetery. (Photograph by permission of R.H. Love Galleries, Chicago.)

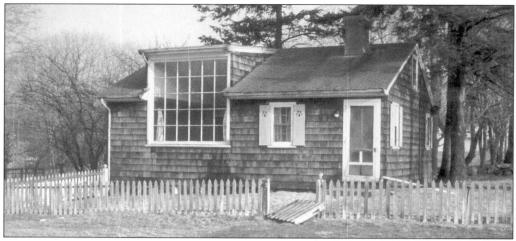

Wood's studio, which is behind the house at 232 Main Street, was built to his design as an artist studio. It is a one-room structure with a bathroom. The area off the front entry has storage units with a ladder going to a loft-sized attic; a two-story window takes up the back wall of the main room. It is presently the office for the Rutland Historic Commission. His original studio was built at 57 Maple Avenue.

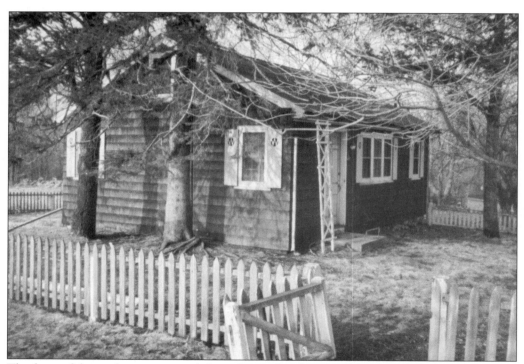

The front of the studio was accessed through a garden from Franklin Wood's home at 232 Main Street. The side of the two-story window was in the back of the building with a view of the mountains as far away as New Hampshire. At the time it was built, the town had not acquired the land that is now Memorial Field, which was dedicated in honor of WWII veterans.

38

This etching, used on the program for the First Congregational Church, was done by Franklin Wood and bears his gift box signature.

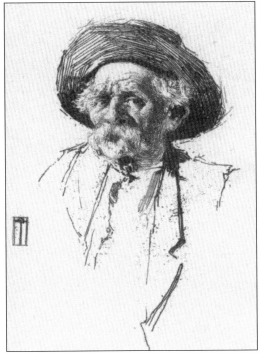

This etching of a local farmer, Mr. Childs, is entitled *Master of Rose Hill*. It was recently included in a brochure of Wood's works from the R.H. Love Galleries of Chicago. His gift box signature is very prominent in this etching. The Rose Hill mentioned in the title was on East Hill Road. Many of his works were of Rutland scenes and people. His last show was in New York at the Grand Central Galleries in 1936. Franklin T. Wood's etchings are in the Library of Congress, the Smithsonian, the Chicago Art Institute, the Worcester Art Museum, and the Museum of Fine Arts in Boston.

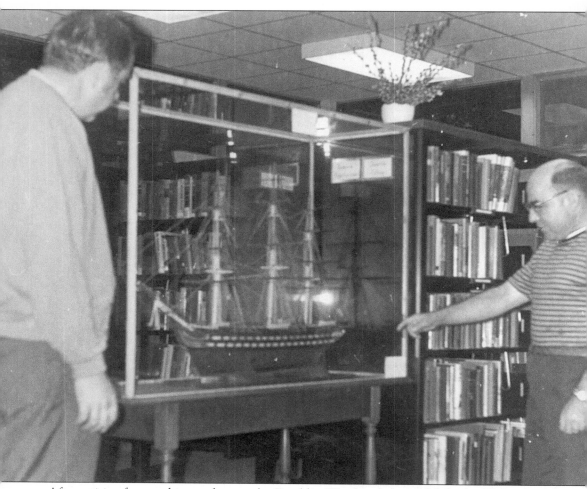

After retiring from etching and art works, Franklin Wood took up model shipbuilding. This model was given to the town by his wife, Hazel Wood. It was in the Rutland Public Library for many years and is now part of the Rutland Historical Society collection. Here, it is admired by George Dalianis (left) and Carl E. Griffin. (Photograph by John Delay.)

Two
WEST RUTLAND

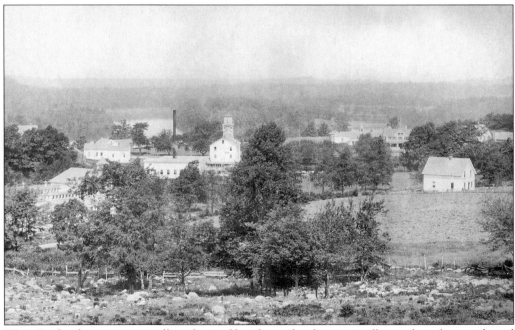

West Rutland was once a village by itself with a school, a post office, a burial ground, and manufacturing plants. The most prominent mill owner was William Stearns, who manufactured satinets. His first mill burned and he rebuilt at another location. He owned most of the buildings in West Rutland and rented to mill workers. He also built and owned the store there. When he died, his wife and her son carried on the business. Eventually, the MDC bought the land for the watershed and most of West Rutland ceased to be, with the exception of the cemetery that stands by Long Pond boating area.

The Stearns house was owned by William Stearns's son. Fred became the general manager of the mill after his father's death and carried on the business with his mother. The house was located near the store in the village center.

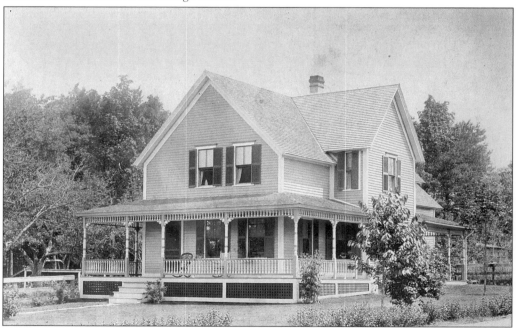

Joseph Ware was one of the few people in West Rutland village who owned his own property and house. He held various positions at the Stearns mill. He is sited as having donated the lower section, made of chestnut, of the 60-foot flagpole erected in 1919. The other half was of spruce and was removable. The pole stands on the spot of the first meetinghouse.

This section on Barrack Hill Road shows three of the oldest houses left in West Rutland. The house in the distance on the right is the Hunt house, which has been there since colonial times. British officers of Burgoynes men stayed in the house after arriving in Rutland from Cambridge. The Robinson house on the right and the Stearns house beyond it are built on land that was once part of the Continental Barracks.

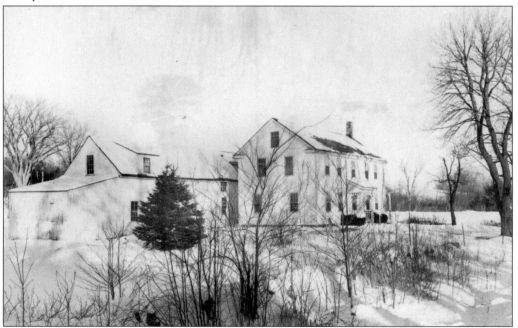

The first house as you enter Barrack Hill Road once belonged to Fred Robinson. He ran a dairy farm there. Miles Holden also once owned the property before he moved to the center.

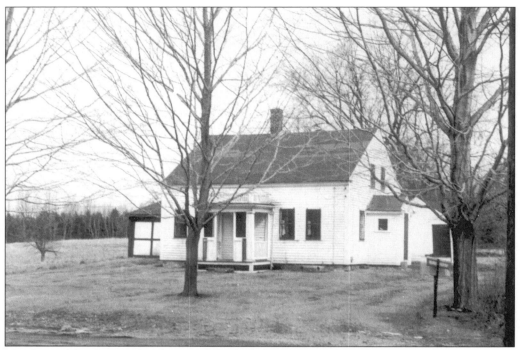

Members of the Stearns family owned the little house across from the Hunt house. It has since been renovated, making it much larger today.

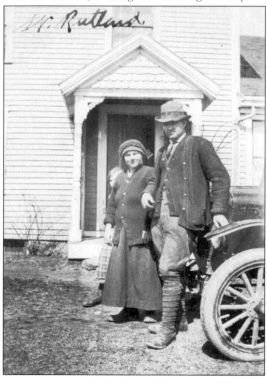

Al Donovan and his wife were photographed in West Rutland in 1925.

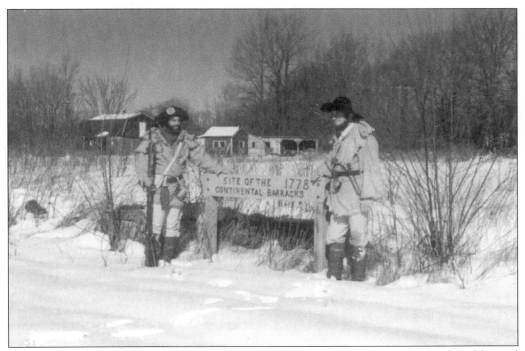

During the American Revolution, Rutland was chosen as a site for a prison camp and housed remnants of Burgoyne's troops, some of which were Hessians. It was the first prisoner of war camp in the new nation. The buildings were known as the Great Barracks. Shown with the Continental Barracks sign at the site are Ray Gaulin (left) and Robert Smethurst.

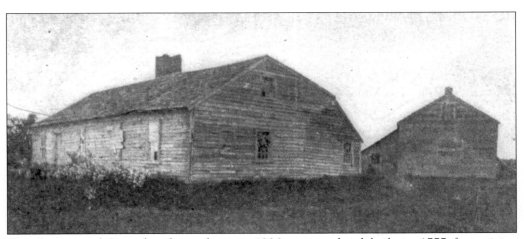

The Continental Barracks, shown here in 1906, were ordered built in 1777 for arriving prisoners of war. In April 1778, some 2,263 British and 1,882 German prisoners arrived. In December 1778, 150 prisoners were left unguarded. Five hundred of Shay's regulators used the barracks in 1783.

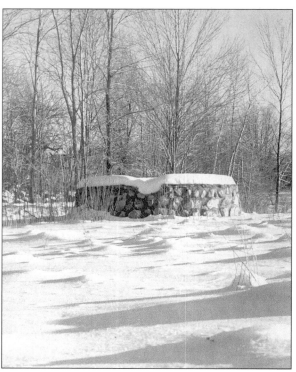

Hessian soldiers encamped at the barracks dug a 70-foot-deep well for water inside the gates. The only remains now at the Great Barracks site is the Hessian Well. According to the *Tercentenary Booklet*, a well curb was built around it in 1930, prior to the tercentenary observances.

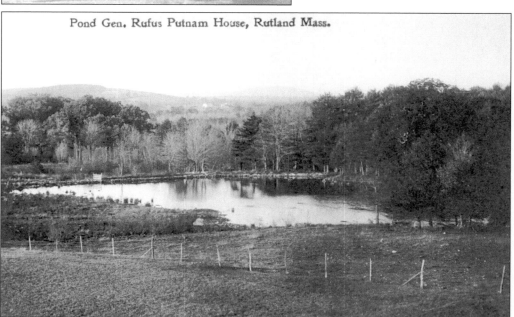

Pond Gen. Rufus Putnam House, Rutland Mass.

The Pond and 17.9 acres next to the Rufus Putnam house was deeded to the "inhabitants of Rutland . . . to be used and forever held as a public park to the memory of General Rufus Putnam and for no other purpose" by Mr. & Mrs. George Endicott in 1951. It had been used as a public beach and park area while owned by the Rufus Putnam Memorial Association since the 1930s. In 1977, the park became a CETA project and paths and nature trails were developed.

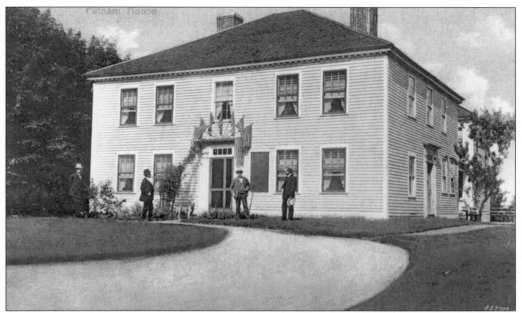

Gen. Rufus Putnam came to Rutland from North Brookfield in 1781 and bought the confiscated home that Col. John Murray had built in 1757. He stayed until 1788, when he and his party left for Marietta, Ohio, to settle that territory. Looking through old town records, one can find the name Rufus Putnam through the 1800s. A relative of his from Warren, with the same name, came to live in Rutland in 1809. He practiced law, was a justice of the peace, and was very active in the town. The Rufus Putnam Memorial Association incorporated in 1901. The organization bought the house and built "in the rear a comfortable dwelling for the custodian and his family," which can be seen in this postcard.

A reenactment of Gen. Rufus Putnam and his party leaving to settle in Marietta, Ohio, was staged in 1907.

H. Edward Wheeler and his family lived at 324 Main Street. Wheeler established a successful ax and hammer handle business and exported goods as far away as Scotland.

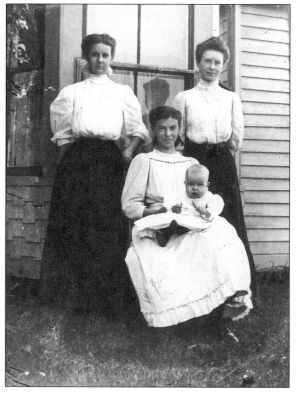

The Wheeler girls can be seen in this early-1900s photograph. They are, from left to right, (front row) Esther and little Phyllis; (back row) Ethel and Edna.

The Allen Elbag house sits off Main Street, just over the hill from the center. Mark Putnam formerly owned it. When the Rutland Fife and Drum Corp brought the circus to town, it set up the show in the fields of this farm.

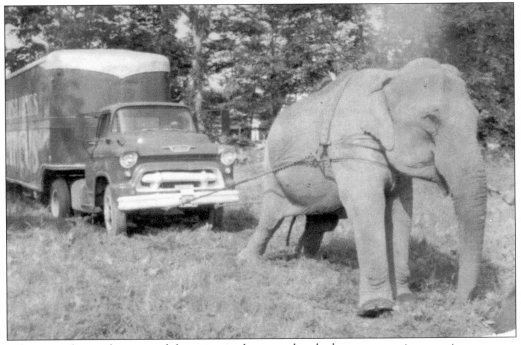

Whenever the trucks got stuck bringing in the gear, the elephant was put into service.

The Beers & Barnes Circus came to town in July 1961 as a fundraising event for the Rutland Fife and Drum Corp. It was held at Allen Elbag's farm at 307 Main Street.

This portrait shows a young Fred Wellington; he was a carpenter and metal worker. He lived to be 92 years old.

The Wellington house sits on the corner of Pleasantdale Road and Main Street. It was brought down from the center and was an addition from the Webber place. It sits on a stone foundation with the date 1923 etched in the cement. It is now the office-kitchen in the home of retired police chief Ralph Anderson Jr. Renovations to the office area revealed an old stairwell, wide floor boards, studs of oak exactly 16 inches apart, horsehair plaster, and trees in each corner of the room. These trees protrude into the room. The building was placed on the site of an old farmhouse cellar hole that is referred to in Benjamin Franklin Stones's booklet as the Buinhall place. An old barn foundation and bottle dump were at the site that is now a horse stall fashioned from an old pump house from the Rutland State Sanatorium. In this photograph, Carrie Bryant can be seen sitting front of the house.

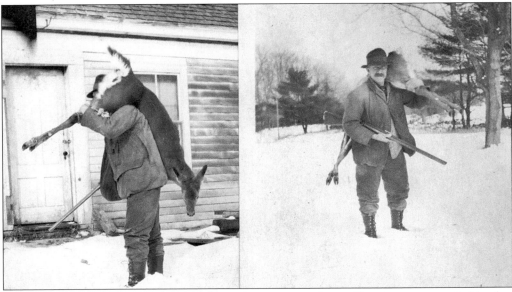

Fred Wellington is shown with a deer from a hunting expedition. Hunting was not a hobby, but a means of earning additional income besides his talents as a carpenter and metal worker. A 1909 receipt shows $7.75 earned minus $.25 for a check for skunk pelts. A December 1911 receipt shows he received $35 for skunk, rats, fox, and mink pelts.

Summer camps abounded in Rutland and many eventually became year-round homes. This two-room summer home at 20 Pleasantdale Road was converted in the 1940s to a year-round home by adding another room and porch. Shown is Ralph Anderson Sr.

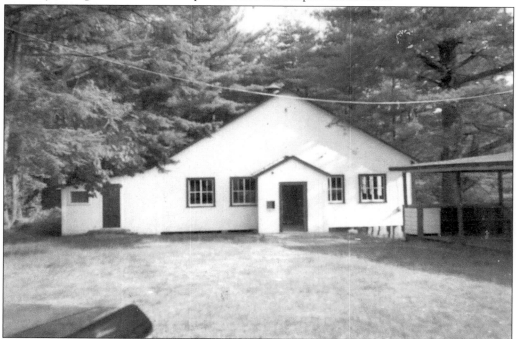

Sovittaja Park is located off Pleasantdale Road, part way between Route 122 and 122A. The 12 acres around Demond Pond was bought in 1925 from the Hautio farm by the Finnish Temperance Society of Worcester. In 1927, a hall was built for dances and the Mid-Summer Juhannus Festival. Camps were built around the park and many are now year-round homes.

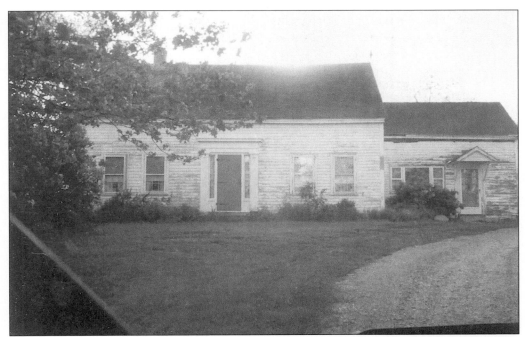

Allendale Farm at 84 Pleasantdale Road is the perfect layout for a farm. The house sits at the end of a long driveway and is nestled on a rise. An expanse of lawn is bordered by towering trees. A barn sits at the back of the house, with a guesthouse nearby. Tucked in back is a three-stall garage with a workshop at one end. It was acquired by the Haines family in 1941 for a summer home from the Hill family. Hill had bought it from the Allens, who owned Allen Shoe in Spencer. They had named it Allendale Farm. The farm was owned in 1898 by C.E. Monroe and previously to E. Muzzy and S. Muzzey. The house dates back to the 1700s. The guesthouse on the property dates to the 1920s. The barn at one time was the largest in Rutland, being 97 feet long with a massive silo for this productive 72-acre dairy farm.

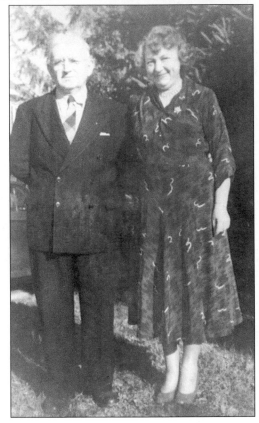

Owners of Allendale Farm, Mr. and Mrs. Paul E. Haines were photographed in 1951. For many years, the Haineses hosted the Winter Carnival snow events for the Rutland Recreational Council.

53

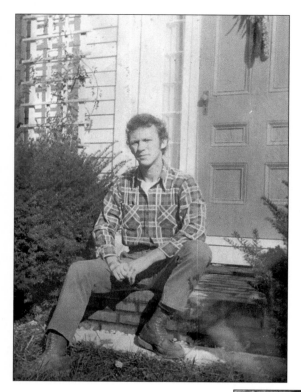

David M. Sullivan was a dog officer in August 1977, when this photograph was taken. David is the author of *The Marines at Bull Run: Emending the Record*, one in a series on the early history of the U.S. Marines. Attention to detail and exacting research make his works not only accurate, but also interesting to read.

Hank Amons of Pleasantdale Road was a well-known entertainer on the country music circuit and recorded several records. "Easy Lovin Woman," "Maybe," and his "No Promise Love Affair" were recorded at Long View Farm Recording Studio in West Brookfield. He also recorded "Back In Time" by Denny Mack. His calling card was his hallmark and read, "Musician Extraordinare, Connoisseur of Fine Booze, Par Excellent Gourmet, Captain of Industry, Social Lion, Art Critic, Songwriter, Master of Ceremonies in Classy Joints, Television Performer, Big Game Hunter, Recording Artist, Super Solo Gigs, Last of the Big Spenders (Temporarily Unemployed)." He was a country singer-comedian who over his 30-year career as a singer and opening act thoroughly enjoyed the stage.

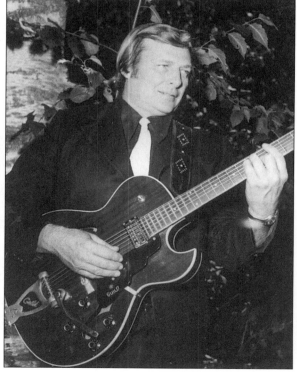

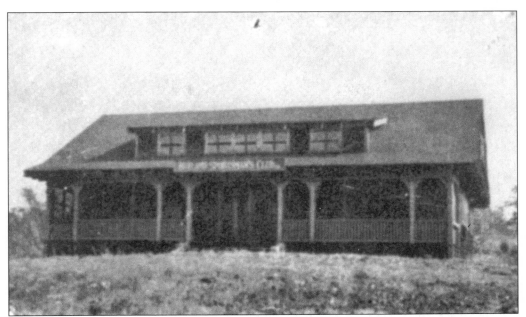

The Rutland Sportsmen's Club was incorporated in 1932 and is located on Pleasantdale Road. This club is very active, offering not only training in good sportsmanship, but functions for families and members. This hall is also in demand for private functions.

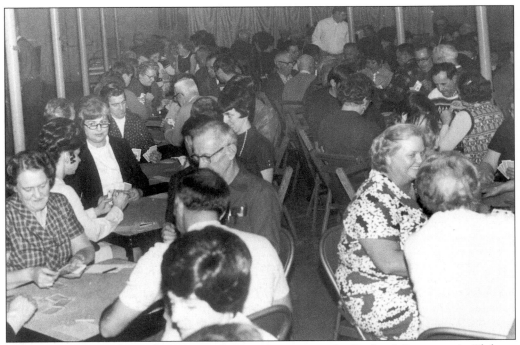

Whist parties (a card game) were popular social events at the Rutland Sportsmen's Club, as shown here. (Photograph by Eugene Kennedy.)

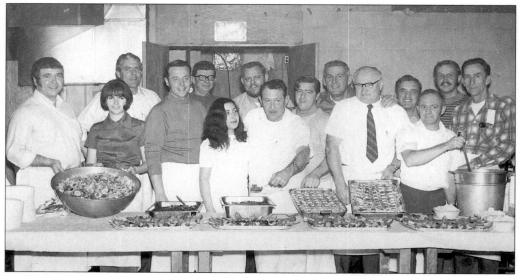

Ready for hungry appetites, this display for the annual game supper is proudly shown by the following, from left to right: (front row) Mr. and Mrs. Donald Slivin, Joseph Dickerson, Gloria Galiana, Morris Sayoy, Walter Holbrook, Arthur Lavallee, and Walter Dolan; (back row) Ralph Johanson, David Eddy, Kenneth Hultgren, Fred Szaban, Joseph Guadette, Robert Scott, and Donald Werme. (Photograph by Eugene Kennedy.)

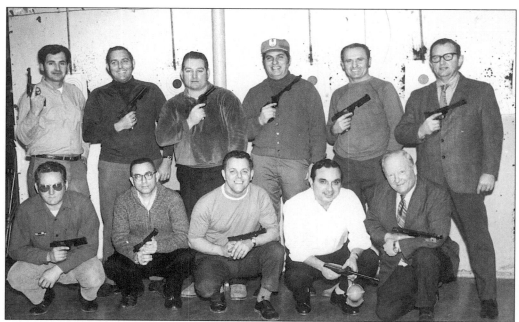

The Pistol Club from the Rutland Sportsmen's Club won its match against the Morgan Construction Pistol Team in 1971. Celebrating, from left to right, are the following: (front row) Andrew Gagnon, Charles Richmond, Robert Zoppo, Joseph Giarusso, and Wilfred Grenier; (back row) Raymond Kerwin, Robert LaBlanc, Jack Fogarty, John Leger, John Komenda, and Leo Grenier. (Photograph by Eugene Kennedy.)

William Johnson was the last owner of the Rutland Diner before it burned. It was located on Route 122 at the four corners. (Photograph by Eugene Kennedy.)

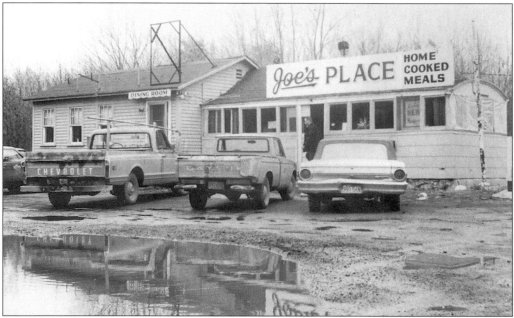

The Rutland Diner, which sat at the intersection of Pleasantdale and Barre-Paxton Road, was destroyed by fire in June 1974. It had been brought to Rutland in the 1940s for Harry Longwell by the Worcester Lunch Cart Company. This diner had been in use in Grafton center. Longwell had developed the corner businesses, comprising of the package store, garage, and diner, out of swampland. The diner still had its wheels attached at the time it burned.

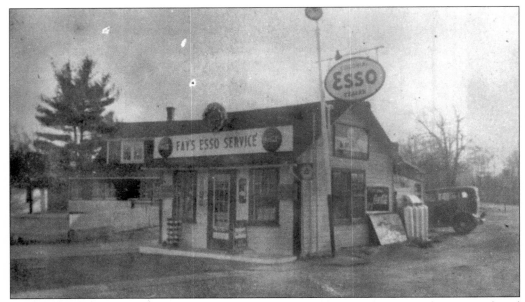

Faye's Esso service station and general store was owned and operated by Fay and Jessie Oughtred for 42 years. It was located at the four corners of Pleasantdale Road and Barre Paxton Road. They also had an automotive repair shop, pumps, and even motel cabins. Their home was part of this business property.

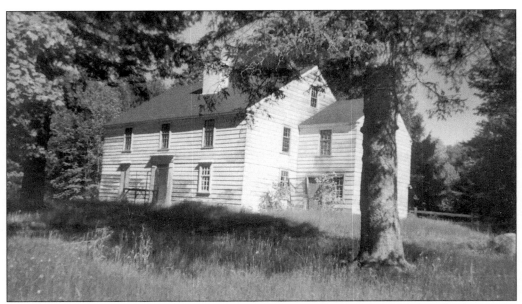

The Springer house at the beginning of Sassawaan Road off Intervale Road dates back to 1756. A board found in the house is dated 1720 and may have been from a previous house on the premises. Abraham Wheeler built the house on the Wheeler farm of 800 acres. Later, the property was sold in 1928 to F. Harold Daniels, who established a forestry camp there. It is presently owned by the Worcester Science Center, now the Ecotarium. It was occupied until 1999 by a caretaker, but stands empty at the present time.

Three

NORTH RUTLAND AND RUTLAND YOUNGSTERS

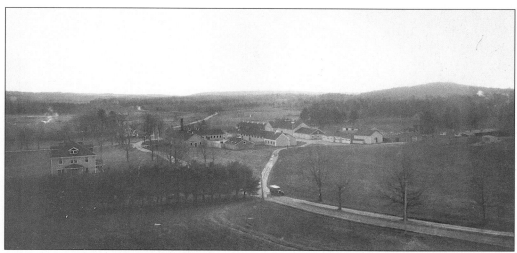

In 1903, a prison camp, or industrial colony, was established on 900 acres in West Rutland, and a tuberculosis hospital was built there in 1905. Frederick Pettigrove, chairman of the Prison Commission for Massachusetts, came up with the idea for temporary camps where prisoners would clear land and then move on to other areas. With the building of the hospital, it became a permanent camp and more land was acquired. At that time, the more violent prisoners were transferred to the Rutland camp and the hospital. The regular prisoners transformed 150 acres into a thriving farm. This self-sufficient operation ran until 1933, when the land was taken as part of the watershed by the MDC.

The Wellington Farm stood just inside the roadway to the new prison camp area off Intervale Road.

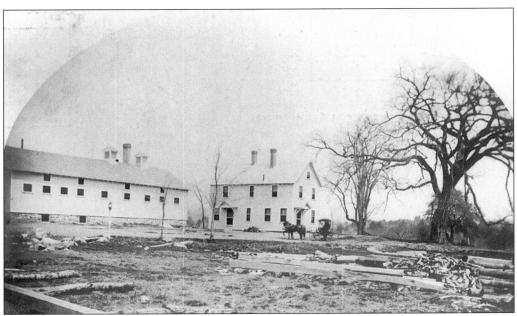

This Massachusetts State Industrial Camp postcard shows an earlier view of the prison camp when it started with the Phinehas Walker house, which served as a kitchen, dining, and storage area. The long building was a dormitory 30 feet wide by 150 feet long that accommodated 50 prisoners and officers.

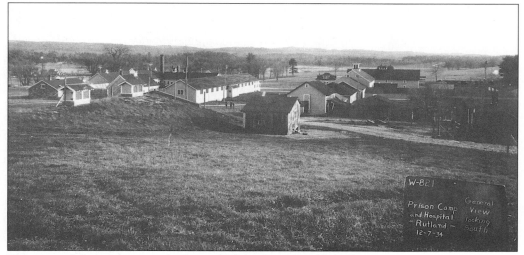

This view of the prison camp looks south from the vegetable cellar.

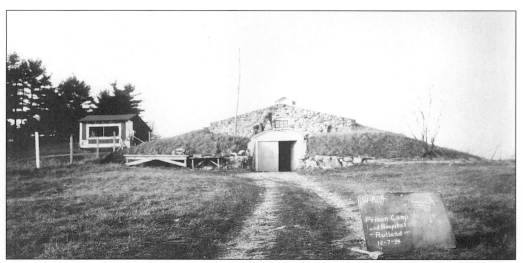

The vegetable cellar was built into a hillside. The upper part was stonework and it was complete with a ventilated cupola and double-door entry. The packed earth maintained an even cool temperature that would not dip below freezing. The structure is very large and was used to store the root vegetables most farmers kept for winter months. These vegetables would include carrots, potatoes, turnips, beets, and cabbage.

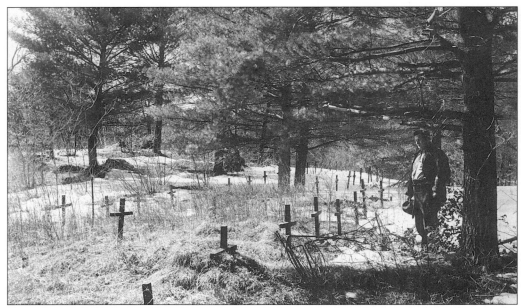

Near Goose Hill Cemetery is the site of the prison camp burial ground. According to the Massachusetts Department of Corrections list, 54 people were listed buried there of the 166 deaths listed. Three names on the sheet are designated as just Rutland and two are listed for the Rutland Rural Cemetery. Each grave was marked with a numbered cross made of iron, as pictured here in this 1941 photograph. During WWII, when the price for iron was up, many of the crosses disappeared. The last one vanished in 1962. None are known to exist today.

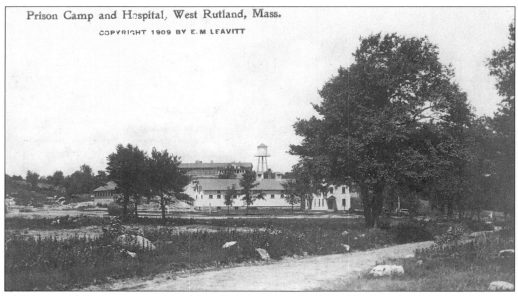

This image of the prison camp and hospital was taken in 1909. The hospital is the building on the hill near the water tower.

According to the *History of Worcester County*, we learn that in 1794, a poor vagrant family consisting of two girls, Polly and Betsy; their mother, Phebe; and stepfather Jonathan Clark took up residence on Charnock Hill Road. They lived in a small one-story cabin, partly underground, built into the southerly side of a hill. It had one room, which the whole family occupied in common, with a single chimney on one side. Clark worked at his trade of shoemaking and his wife worked out in the families of their neighbors. The girls would stay with Reuben Walker and his sister when the winter became bitter. After living in town for three years, they left for North Carolina, where Mr. and Mrs. Clark died in an epidemic in 1798. Betsy went on to become Madame Jumel and when she died in the Jumel Mansion, New York in 1865, she was in her 90s. When relatives contested her will, Mr. Reuben Walker and his sister of Rutland were brought to New York to testify in the case on behalf of Polly's grandchildren. The site of that cabin became the entrance to Goose Hill Cemetery.

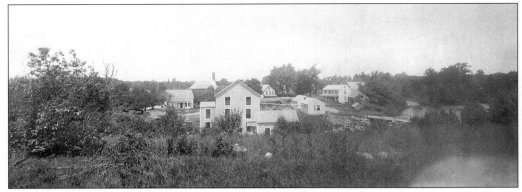

North Rutland was another area of town that was a village complete with its own school, post office, stores, and mills. This village, too, was sacrificed to the MDC watershed project.

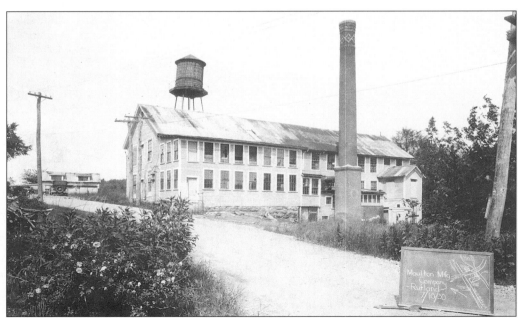

The Moulton Mill was a major employer in North Rutland. The company manufactured woolen goods.

Of all Rutland's many district schools and of the 10 last schools, the North Rutland school closed in 1928 and the West Rutland school closed in 1938. The seventh and eight grade classes were the last to use the West Rutland school, which is now a residence.

This 1936 image shows Moses Sarkisian as a Rutland student.

John Griffin was part of the Rutland 1936 class.

Young Gilman Connor is shown here.

This picture shows Curtis Mahan in 1936.

This charmer is John Thomas in his 1920s Sunday best. He was the son of Mr. and Mrs. Albert Thomas.

We know that Christine Marsh was a beautiful baby from this 1948 photograph by Albert Thomas. She now resides in France.

The Nurmi children from Pleasantdale Road are, from left to right, Margaret, W. Daniel, and Patricia.

Bill Temple is shown here with his children, Russ and Patty. In the background, you can see Jean Cormick's house at 119 Main Street when it was still on the side of the road in 1946. The road was redone in 1950, leaving many homes on embankments. David Fletcher carried on a carriage business on this site in earlier times.

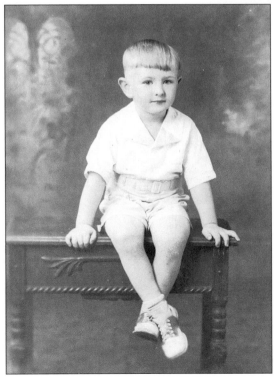

Ralph Anderson Jr. strikes a pose on his third birthday.

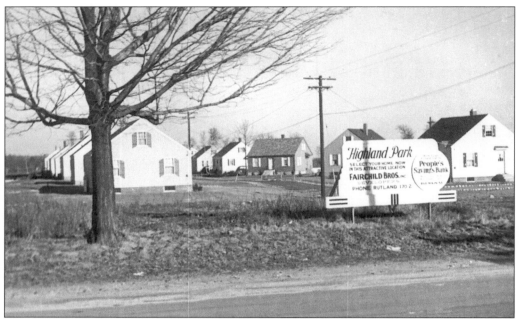

Highland Park was one of Rutland's first housing developments. The Fairchild Brothers built it in 1946.

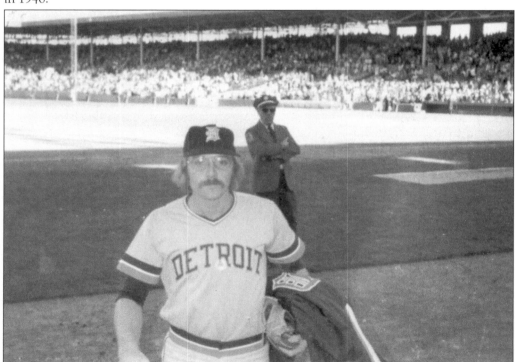

Bruce Taylor of Highland Park played for the Detroit Tigers. In this photograph, he is leaving Fenway Park in September 1977. His career was ended by injuries. His card is a collector's item, but no one is releasing any in Rutland.

Four
BUSINESSES

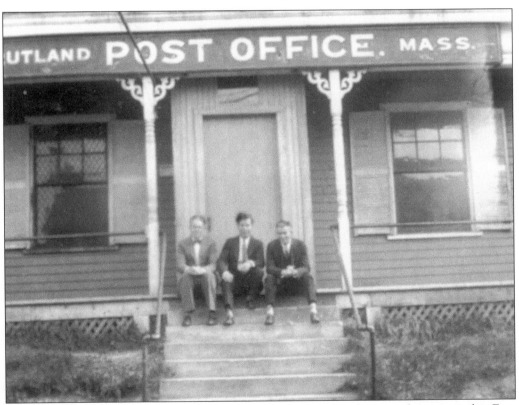

This building on Maple Avenue was originally the school that stood next to the First Congregational church. It was moved to Maple Avenue and served as the post office for some time. It is now the Maple Apartments. This picture shows Albert Thomas and friends at the post office in 1926.

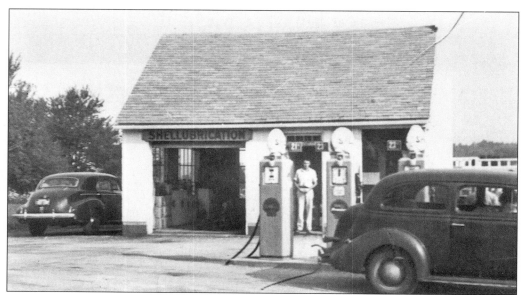

Standing in the doorway is William Temple at his Shell station on Pound Hill (Main Street) and Glenwood Road. Pound Hill got its name because the pound where stray animals were brought was not far from this site. Also in this area was one of Rutland's forts during her earlier days.

The Daniel Nihin House was part of a farm and was, at one time, a private sanatorium. This picture shows the farmhouse of the Nihin property with Rutland Plaza visible. The house was razed in 1976 and the Spencer Savings Bank now stands near the site.

The Red & White grocery store opened for business in 1938 at its Maple Avenue location. Ernest and Chatty Bigelow ran the business until the end of 1970. Beside the store, the couple had a real estate and trailer park business.

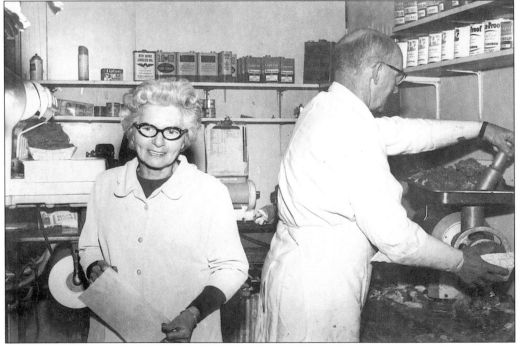

Ernest and Mary "Chatty" Bigelow can be seen hard at work.

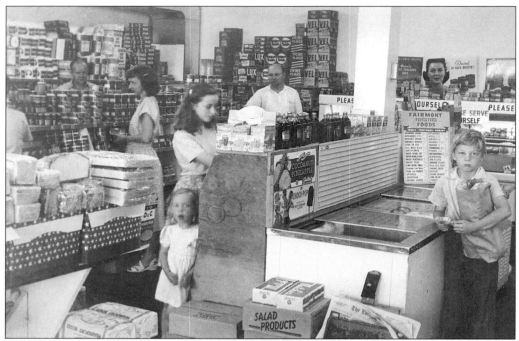

This picture shows an inside view of the Red & White store in 1948.

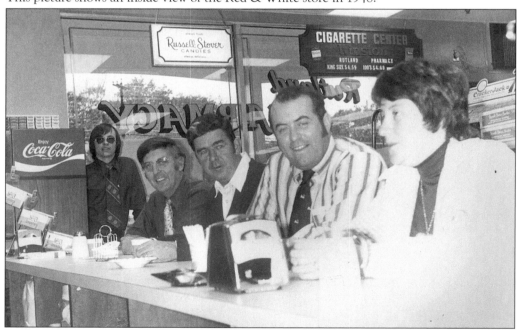

Rutland's first pharmacy of recent times opened in Rutland Plaza, at 80 Main Street, in 1974. It was a joint venture of three pharmacists—Mel Mastrodomenico of Lancaster, David Tuttle of Sterling, and William Hale of Holden. David Tuttle still runs the pharmacy, which is now on Maple Avenue. Pictured, from left to right, are Dave Tuttle, pharmacist; Mel Mastrodomenico; Bill Griffin; and William Hale.

Five

TRAIN SERVICE

BOSTON & MAINE R.R.

RUTLAND, Mass.
TO
Worcester, Mass.

3141

2605

This railroad ticket represents a bygone era in Rutland's history. Harold Judkins, who worked for the railroad, explained the progress of the railroad with the following details: In 1885, the Massachusetts Central was reorganized as the Central Massachusetts. Railroad rails were laid through Muschopauge on November 10, 1886, and through Rutland a month later. The line reached to Ware in June 1887. Regular service was started June 20, 1887, with three passenger trains each way. Northampton was reached in December 1887, and through service from Boston was started with three passenger trains to Northampton and one to Ware. In 1890, the railroad had five passenger trains each way and a number of freight trains. The congestion of traffic became terrific. The discontinuance of some through trains helped reduce traffic a little, but in the early 1900s, with three passengers each way, three regular freighters, and extras up to ten a day each way, gave the various station agents and telegraph operators a good day's work, since all trains were dispatched by train orders. The operator occupied many stations, including the one in Rutland, 24 hours a day.

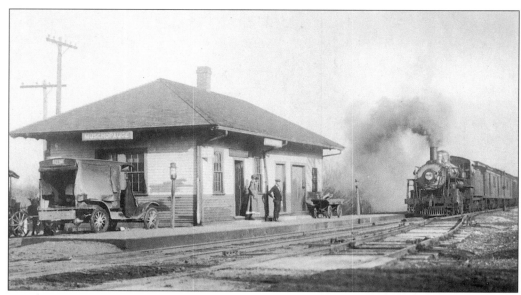

Muschopauge Station was near Route 68. Martha Smith was agent and caretaker at Muschopauge for 34 years from 1898 to April 1932, when the last passenger train went west. The last freighters went through on September 15, 1938, the day of the hurricane. Two washouts near where Route 122 crossed the roadbed in Coldbrook ended all service. Rutland was the only service west of Oakdale not served by another railroad. The automobile and Prescott's bus line with 16 trips a day took the passenger business.

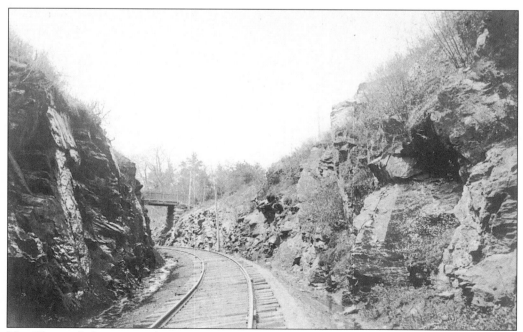

The Charnock Cut appears here, c. 1911. This pass was blasted through granite. Its curve would create problems for trains, especially in winter.

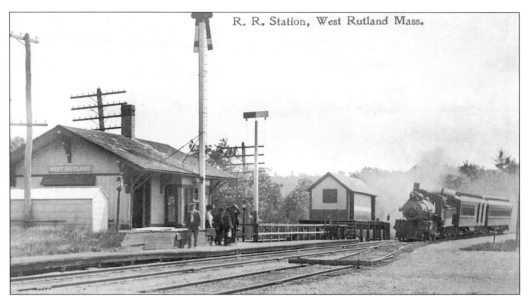

R. R. Station, West Rutland Mass.

The West Rutland station was located on the road that leads to Rutland State Park.

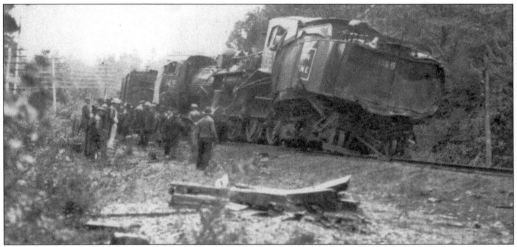

"There were several wrecks on the line and no wonder," Harold Judkins writes, "with the density of traffic and the human frailty of judgment. An engineer could be holding three or four orders for meets of trains and in the long hours of struggling from one meeting point to another, have a lapse of responsibility and cause a wreck. A fourth section of a freighter west ran into the rear of the third section stopped for water and parts of the wreckage went into Calkins Pond. At a washout this side of Charnock Cut, where in winter a man was there 24 hours a day to chop the ice along the walls, there was at West Rutland, a train that crashed a caboose, setting it on fire and causing the death of the brakeman. In the storm of 1888 a train stalled between Pommogussett Road and the station for several days. There was a train wreck 3/4 miles east of Rutland Station at the left hand curve August 3, 1932 at 1:55 PM caused by the Dispatcher in Greenfield filling 1435 East's rights to Oakdale when it should have read Rutland. The 1365 West properly had the right from Hudson to Rutland. Both men in 1435 were killed; the 1365 was on the inside of the curve and could see the other train. The fireman on 1435 was working the fire going up hill to the summit, otherwise he too could have seen the other train."

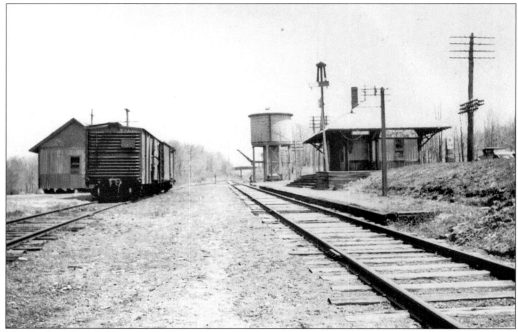

Shown here is one of the stations before it was demolished after the 1938 hurricane ended all business, due to washouts and little business.

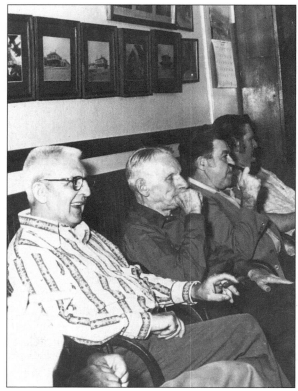

Harold Judkins relaxes with friends Roland "Pop" Miller, James Wood, and Ralph Anderson Jr. at old timers night.

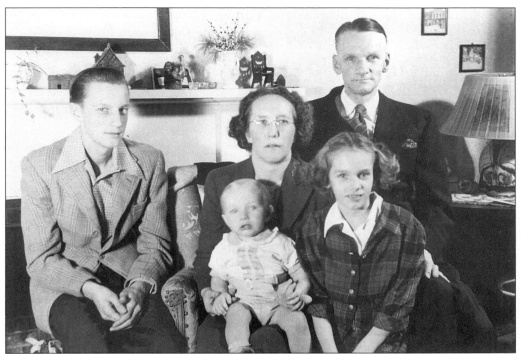

Albert Thomas took this family portrait in 1948 for the Judkins. Seen, from left to right, are the following: (front row) Jane and Judy; (back row) Robert, Charlotte, and Harold.

The Judkins family home is on Main Street. The old railroad bell sits near the porch. (Photograph by Albert Thomas.)

The old railroad bell was photographed by Albert Thomas.

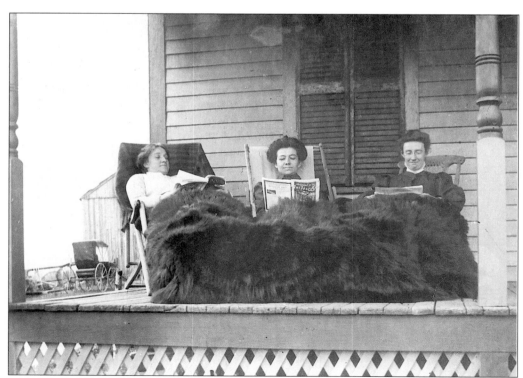

These women are taking in the good Rutland air.

Six

HOSPITALS AND SANATORIUMS

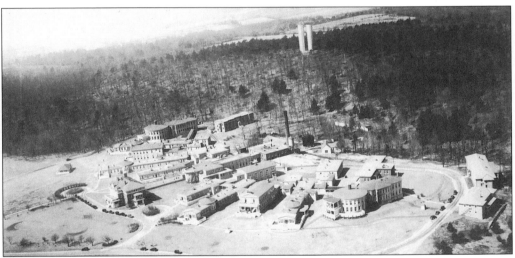

Rutland was chosen as the site for the first tuberculosis hospital. The Rutland State Sanatorium was approved in 1895, opening in 1898. Rutland's first patient was admitted October 3, 1898. He was allowed to stay only one year, then was sent home, where he died within the year. In 1900, Dr. Bowditch recommended that the stay be longer and, with the numbers of cases increasing, a screening for the earliest cases was instituted and led to the "dictum that one could not be admitted to the Rutland State Sanatorium if one had a cough." The prevalent treatment was "constant and copious potations of the beautiful Rutland fresh air, day and night." Dunham beds allowed patients to have the bed project out of a window, so the patient was in the air all night or patients were left on porches and "the first thing the nurses and orderlies did when reporting to work after stormy nights was to dig their patients out of their respective snow banks." Nutrition and rest were important parts of the regimen, but the patients were also required to work.

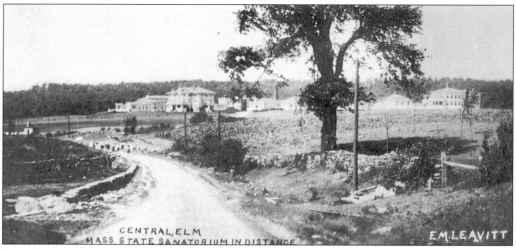

An elm tree on what was once part of the Harvard Turnpike was situated at the exact geographical center of Massachusetts. At some point, that section of the Harvard Turnpike was name Central Tree Road. The Central Tree Elm became infected with Dutch elm disease and had to be cut down in 1966. In 1972, a sycamore was planted on the site. The tree died and a red crimson maple was planted there and is still thriving today.

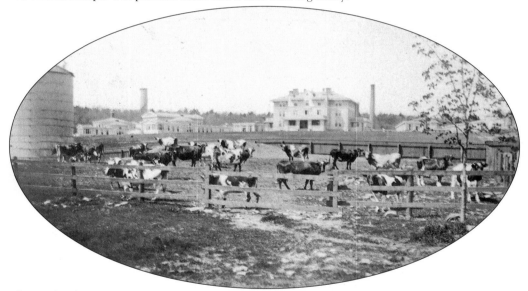

The Rutland State Sanatorium operated a farm, which produced much of its needs. The trustees stated, "after conceding that rest is a necessity for the active and feverish patients complete inactivity is harmful, for while they gain flesh, they do not gain strength. It is recognized that every sanatorium should supply some occupation for the patients committed to their charge. These occupations were any and all manner of housekeeping and attendant work, anywhere from one to five hours a day, without pay. Baseball games were recommended, vegetable gardening and haying was considered favorable for two or three hours a day." They served 25,381 patients for tuberculosis until closing as a tuberculosis hospital in February 1963. The entire facility was closed in 1965. The 16-building facility had a 350-bed capacity and employed 250 people, many who lived on the premises.

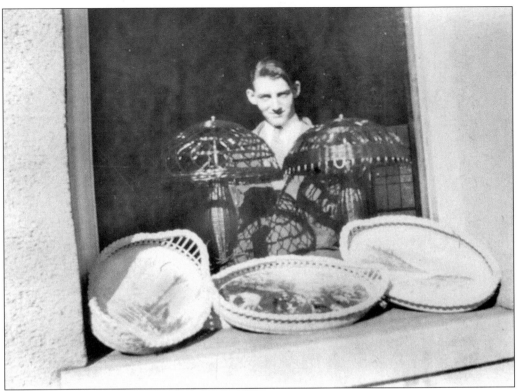

In this photograph, Al Sullivan displays some of the reed baskets he made in 1925.

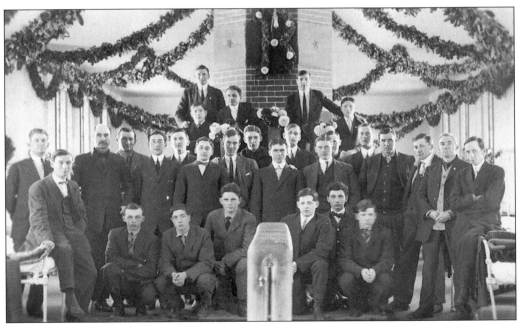

This Christmas celebration at the sanatorium took place on Ward B in 1912.

In 1925, Al Thomas and friends from Ward E stepped out for some sunshine and fresh air at the Rutland State Sanatorium. Shown, from left to right, are Mr. Clark, Mr. Morgan, Mr. Thomas, Mr. Dickman, Mr. McAuliffe, and Mr. DeVittea.

Visitors to the state sanatorium got as much air as the patients. Visiting Al Thomas in 1925 are Mr. MacCauliffe's wife, and Mr. MacCauliffe's mother, Mrs. McGlone, and Mrs. Thomas.

Dr. Olin Pettengill, one of the sanatorium doctors stops long enough to be photographed, c. 1916.

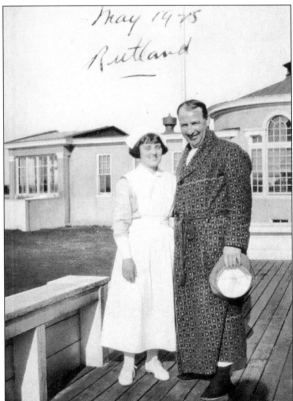

Ada Fowler and Dan McAuliffe celebrate her graduation in 1925. A training school for nurses was started in 1909 and those patients who trained as nurses or support staff would find ready employment.

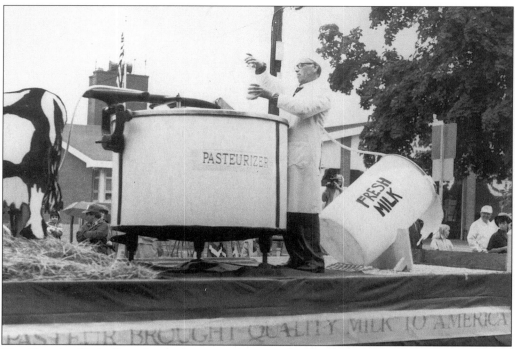

One Fourth of July float shows the pasteurization of milk. From 1924 to 1925, some 10,000 children were examined and 29 percent were found to be infected with tuberculosis. It was found that bovine tuberculosis was being spread through milk from infected cows. The destruction of the infected animals and the pasteurizing of milk almost eradicated juvenile tuberculosis. (Photograph by Eugene Kennedy.)

Fr. James O'Connor appears at the Rutland State Sanatorium in 1916.

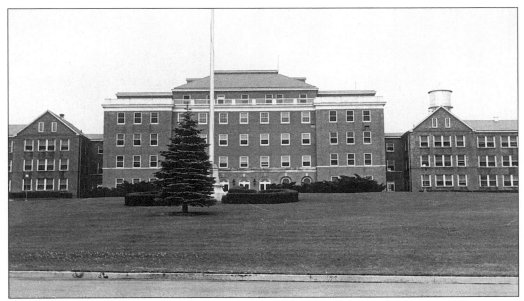

The Veterans Administration bought buildings owned by Dr. Bayard Crane and 86 acres of land. They built the Veterans Administration Buildings at Rutland Heights. It opened in 1923 and served as a veterans' hospital until 1965. The VA had 51 buildings, a capacity for 618 beds, and 592 employees. In 1965, it was leased to the state, and the patients from the Rutland State Sanatorium were transferred there. It was renamed Rutland Heights Hospital and became a long-term care facility until 1991, when it was closed and slated for demolition.

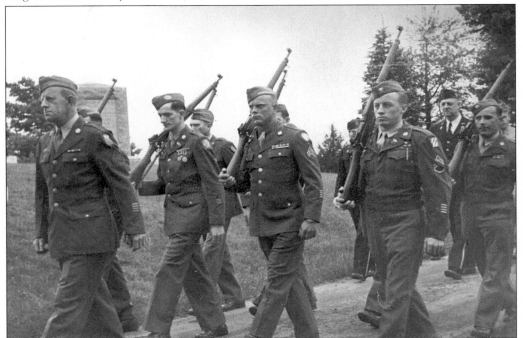

Veterans of WWII never failed to march on Memorial Day. Those shown, from left to right, are an unidentified man, Edward Turner, Arne Hagman, ? McGann, and Bill Suchocki.

In 1959, the staff at the Veterans Hospital was honored with performance awards. Those known to be in the photograph, from left to right, are as follows: (front row) unidentified, Sarah Brown and Delia Anderson; (back row) unidentified, unidentified, unidentified, Tony Kappello, Edward Storey, Mr. Morse, Tom Hogan, Arne Hagman, Paul Novak, and Ellen Gordon. The *Holden Midweek News* listed Rutland recipients as Arne Hagman, Sarah Brown, Delia Anderson, Ellen Gordon, Philip Moray, Madolyn Pendelton, Edward Storey Jr., and Doris Wilkins.

The Rutland Heights graduating class for nurses aides included, from left to right, Wendy Dybik, Rita Lowe, Mary Hayden, Margaret Brown, H. Laura Eddy, Elizabeth Janauskas, and Ellen Nowicki.

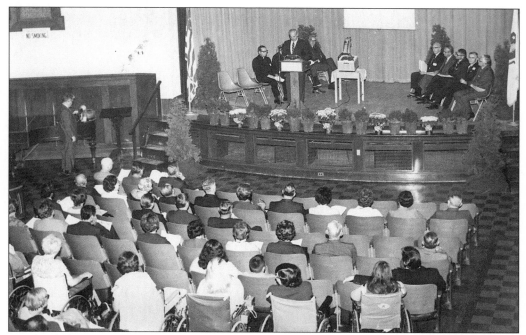

On the fifth anniversary for Rutland Heights Hospital, a ceremony was held in the theater of the hospital. Speaking at the podium is Dr. Herman LaMark. Seated, from left to right, are Rev. Edgar Pelletier, Dr. Malcolm Sills, and Senator Foley (behind speaker), Rep. Edward Harrington, Dr. E.K. Brunner, Alfred Frechette, Dr. Harry Allen, Rev. C. Paul Bush, and Rev. Walter Squibb. (Photograph by Eugene Kennedy.)

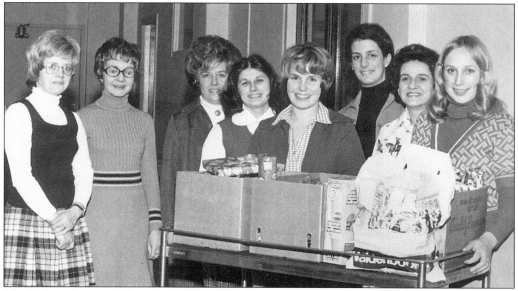

The Xi PSI chapter of Beta Sigma Phi sorority took the time to distribute gifts and refreshments at Rutland Heights. Shown, from left to right, are Mrs. Carlton Perry, Mrs. Brenda Barr, Mrs. Robert Zoppo, Mrs. Patrick Sarkisian, Mrs. James Conley, Mrs. Robert Goyette, Mrs. Floyd Isble, and Lena Ambrose. (Photograph by Eugene Kennedy.)

The boarded buildings of Rutland Heights Hospital await demolition.

Nelson Calkins (left) and Sen. Robert Wetmore tour the closed facility.

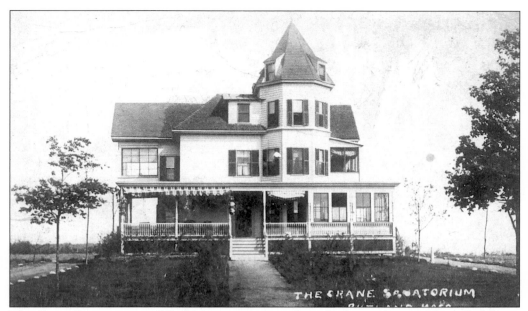

The Crane Sanatorium on Maple Avenue is across from the hospital gates. The other Crane Sanatorium bought by the VA was inside the gates. This building is now converted to apartments.

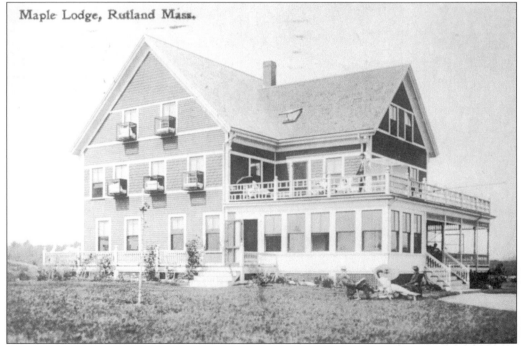

The town had numerous private sanatoriums for those waiting entrance to Rutland State Sanatorium. The Maple Lodge shows Dunham beds protruding from the upper-story windows.

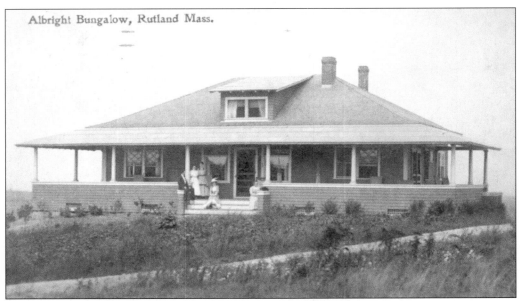

Albright Bungalow, Rutland Mass.

The Albright Bungelow stands across from the end of Memorial Field.

The Central Tree Sanatorium was one of many listed for "Elm Tree Road." However, Anthony's *Standard Business Directory* lists four sanatoriums for Elm Tree Road—one on Main Street, one on Pommogussett Road, one on Princeton Road, one on Wachusett Street, and one on Prescott Street.

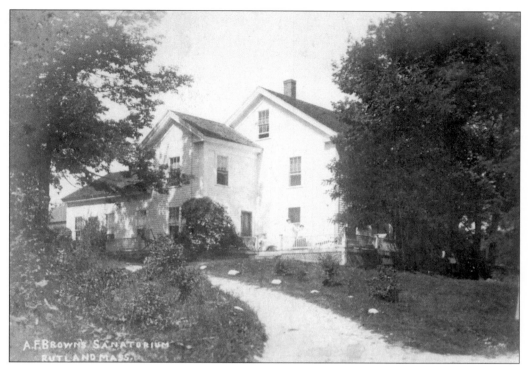

The A.F. Brown Sanatorium on Ridge Road had a location listing on Princeton Road in Anthony's *Standard Business Directory*.

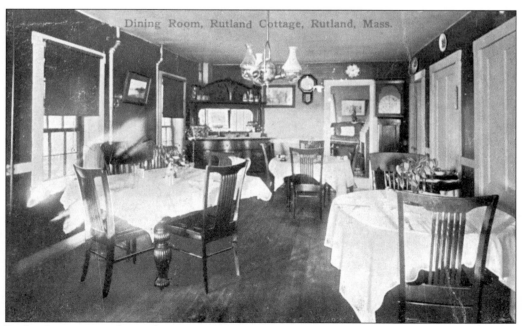

Rutland cottage was located on Prescott Street and was listed to Dr. David P Butler Jr. with an office on Maple Avenue.

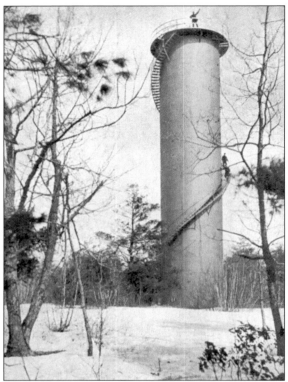

The standpipe on Muschopauge Hill was first filled in 1896. The standpipe reached a height of 1,353 feet 3 inches above tide water. In 1974, the town voted to build a concrete water standpipe and the old standpipe was torn down.

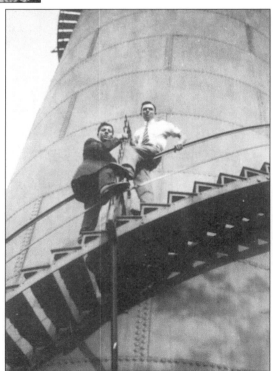

Climbing the standpipe was one form of exercise and amusement.

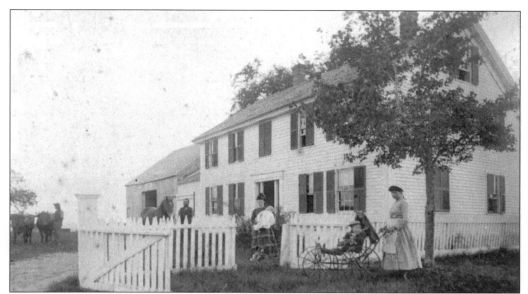

The Hunt House on Barrack Hill Road was built in the 1700s. It was used for officers' quarters during the time of the occupation of Burgoyne's men as prisoners of war at the Great Barracks across the roadway (1778). The original owner is listed as George W. Pierce, and its use was listed as a stagecoach stop and a residence. The house came into the Hunt family in 1898, about the same vintage as this old photograph of the family. (Courtesy Mr. and Mrs. Edward Sheridan.)

The Hunt House was put on a foundation during the Depression, which raised it quite a bit. The basement that extends to the barn area has a full wine cellar.

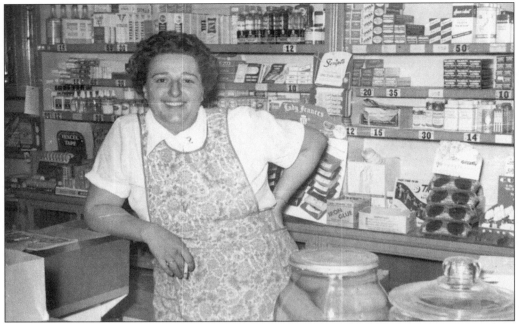

Happy Valley on Central Tree Road was a variety store run by Rita and Joe Canney, who did a major part of their business with staff and patients at the Rutland State Sanatorium. Rita can be seen at work in 1951.

Hailstones the size of baseballs fell just before the tornado of 1953 plowed through town. Rita Canney took a picture of this one next to a flashbulb at her store, Happy Valley on Central Tree Road. (Photograph by Rita Canney.)

Seven
TORNADO

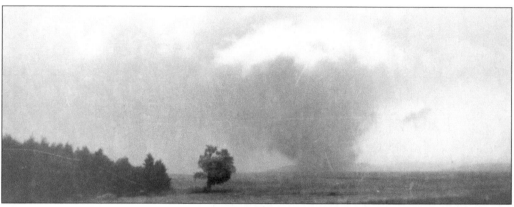

Rita Canney got the only picture of this funnel cloud as it touched down off Central Tree Road. On June 9, 1953, a tornado tore through Worcester and the surrounding towns. It came through Rutland in the early evening at five and tore a path just below the center of town. Tornados were unheard of in this part of the country at that time. It demolished or damaged 45 homes, killed two people, and hospitalized 60 people according to some reports. It had a forward speed of 32 mph and a width of 450 feet at one point, according to author John O'Toole, who wrote a history of that storm. The average wind for a Class 5 tornado is 260 mph and the average track is 2 miles. This one had winds of 325 mph and tore a track for 42 miles.

Homes were torn from their foundations and rubble, roofs, and cars ,were tossed in the air. Property damage was estimated at $368,000. Killed were Donald Marsh and Robert Harding. In a magazine article, O'Toole said, "The story of the Marsh family in Rutland was incredible. They were sitting at the table having supper when the house just blew up. Donald Marsh was killed. Midge, his wife, was badly injured. Linda Marsh was thrown through the air and impaled, with her two feet off the ground, on the broken stub of a maple tree. They cut her down with a chain saw and brought her to the Rutland Hospital, and operating with emergency generators they were able to remove the branch. It didn't touch any vital organs, and she lived. A neighbor turned over Donald Marsh, found no sign of life, turned away and heard a muffled cry. He turned back and turned the body over and found little Dwight, 20 months old, under his father, okay." Robert Harding was killed on his way to the cellar.

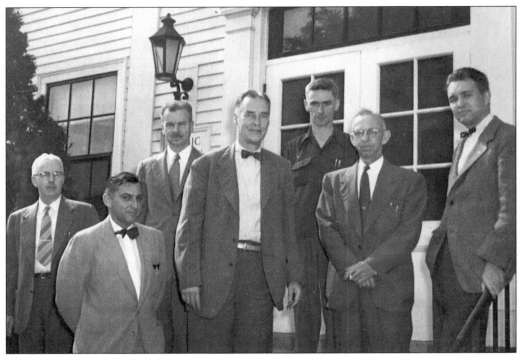

After the tornado of 1953, Gov. Christian Herter and other officials came to Rutland to assess the damage and needs of the community. He appointed the Central Massachusetts Disaster Relief Committee. Shown, from left to right, are the following: (front row) the governor's secretary, Gov. Christian Herter, and Donald Lincoln, (back row) Frank Brooks, Dr. Dayton VA, Civil Defense Director Edward Story Jr., and Rep. Paul Hinckley.

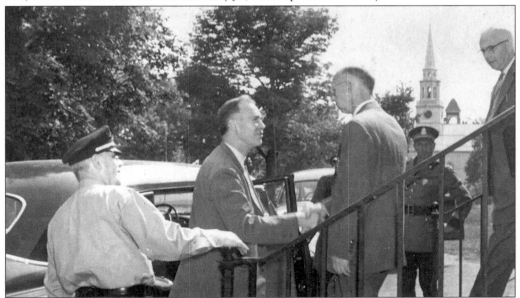

Gov. Christian Herter greeted selectmen. Shown, from left to right, are police chief John Collins, Gov. Christian Herter, Donald Lincoln, and Frank Brooks.

The Holbrook Barn, across from the Rutland Rural Cemetery, was damaged by the tornado and later torn down by the fire department.

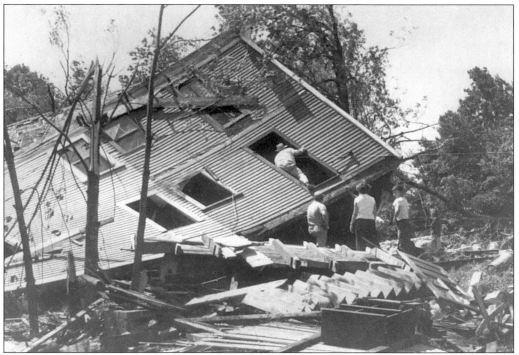

The Hopps-Moisio home on Main Street was destroyed. Mrs. Moisio and a visitor were thrown clear of the house.

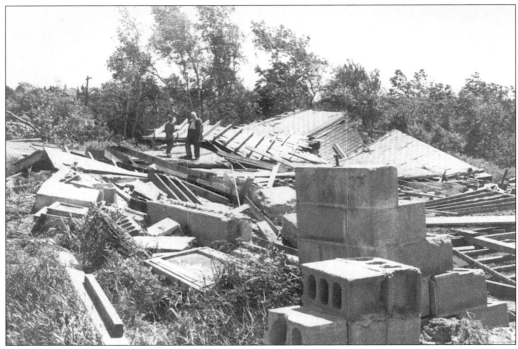

The tornado leveled the Prescott poultry house.

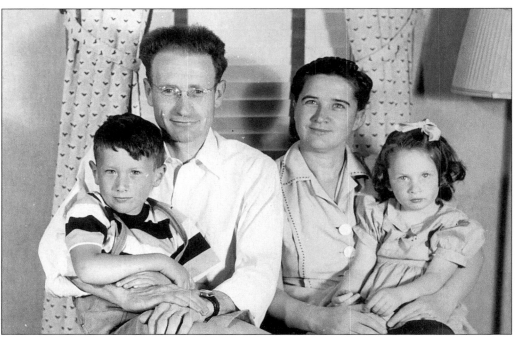

Albert Thomas took this 1948 family picture for the Prescott family. They are, from left to right, Gordon, Lloyd, Nora, and Susan.

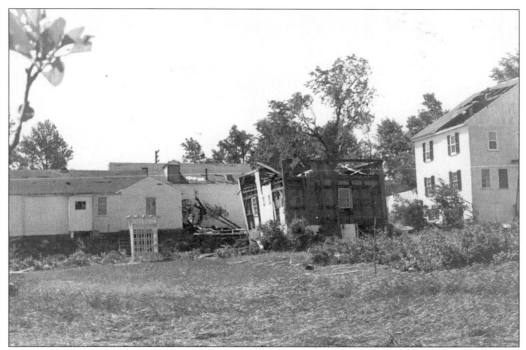

The Monadnock Lodge at 216 Main Street was damaged by the tornado. Ethel Moore's garage at 212 Main Street was demolished when the tornado plowed through.

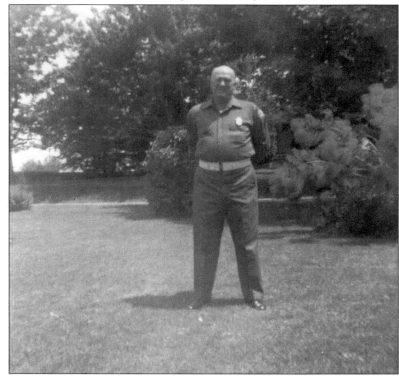

Civil defense officer Norman Jones was called to duty and spent several nights with others, including boy scouts, protecting property from looters.

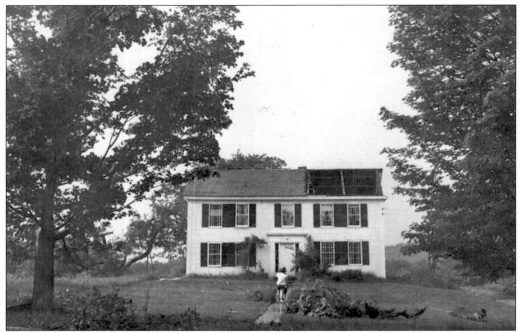

The Gagnon house at 166 Main Street suffered roof damage from the tornado.

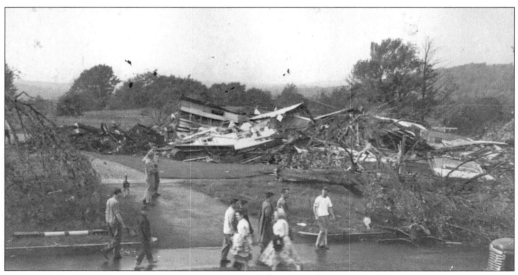

The Maurice Gordon house at 190 Main Street was demolished.

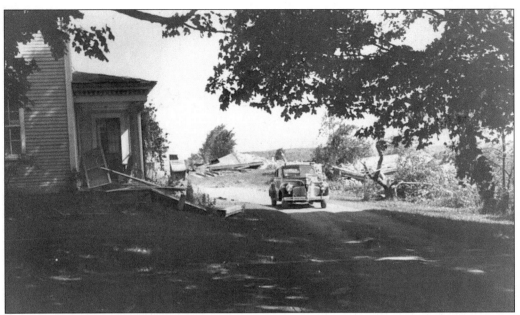

The Proutys' barn was demolished by the tornado, but the house at 228 Main Street survived.

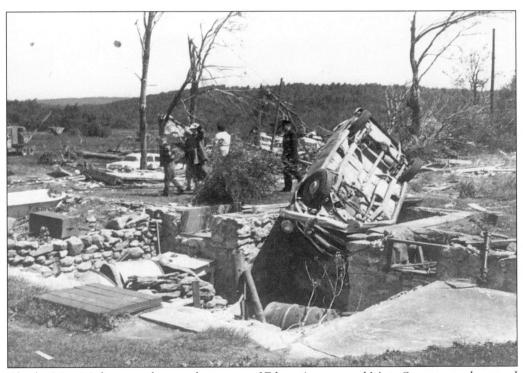

Charles Martin's home and car at the corner of Edson Avenue and Main Street were destroyed and he was injured.

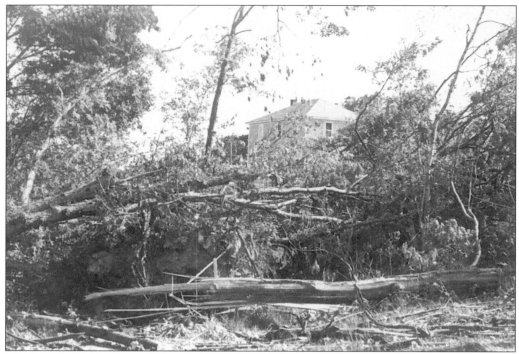

The tornado uprooted large trees behind the Alinovi House on Pommogussett Road.

Attilio Alinovi was a town leader from the old school. Before he made a decision or agreed to anything, he made sure he knew what he was doing and if it would be in the best interest of the town. "T" was not one to be forced into making minute decisions on any pretense. He served on the school committee and other boards, including the Rutland Finance Committee, the Wachusett School committee, the Rutland Planning Board, as a building inspector, and several terms as a Rutland selectmen.

Eight
THINGS TO DO

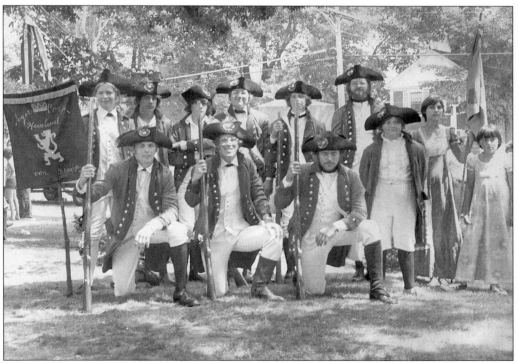

This troop of Hessians was formed because of Rutland's involvement with the Hessians as prisoners. Although Rutland's Hessians were dragoons, it was impossible to find mitred hats, so a yeager corp and a rifle corp was imitated instead. The Hesse Kassel von Donop troop is pictured before one of the town events. Shown, from left to right, are the following: (front row) Joe Raskett, Dennis MacCallum, Roger Mann, and Kathy Anderson; (back row) Robin MacCallum, Gary Leslie, Tom Reando, Chris Shipman, Daniel Gaffney, Mark Humes, Cheryl Ahearn, and Christine McCabe.

Elaine and Bill Suchocki were an integral part of the troop. Bill taught the boys to march and Elaine made most of the uniforms. They traveled with the troop throughout New England. They were also active members of the Rutland Fife and Drum Corp. Shown, from left to right, are Mrs. and Sen. Robert Hall, Bill Suchocki, and Elaine Suchocki.

Thomas Eustis Militia on Memorial Day 1971 was the original troop for reenactments during Rutland's 250th anniversary celebration. At first, they went into battle with the American Legion's MIs until money was raised for Brown Bess's. Here, the Thomas Eustis Militia takes a break. From left to right, they are as follows: (front row) Joseph Raskett, Todd Anderson, Kathleen Anderson, Ralph Anderson Jr., Roseanne Leslie, and Kim Kennedy; (back row) Roger Mann, John Kennedy, Chris Shipman, Bobby Marshall, and Kevin Marshall.

Paul Cousineau Jr. (right) exchanges ideas with a visiting reenactor during an event on the town common. He later saw actual service with the U.S. Marines during the Gulf War. He was stationed in Saudi Arabia, having been transferred from Norway.

Jeene Collins models an 1800s green raw silk wedding dress owned by Charlotte Judkins.

When FORE (Friends of Rutland Education) was started in 1974, it replaced the PTA that had been disbanded in May 1973. One of their first projects was a hobby show. Here, Terry Putnam reviews a display.

In 1976, the Rutland Enthusiast again raised funds for the nations celebration. Jackie Szaban (left) presents 1976 Committeeman Terry Graham with a check.

Shown is the 1948 class of Joanne Culver's dance class at their recital.

William Temple with his dog in his favorite wagon enjoy a summer afternoon in the 1920s.

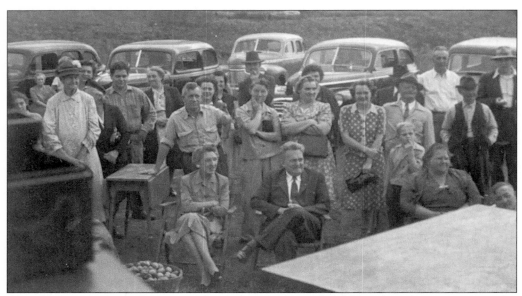

Church auctions always drew a crowd and continued into the 1980s, when they gave way to flea markets. This one in the 1940s included vegetables as well as household goods.

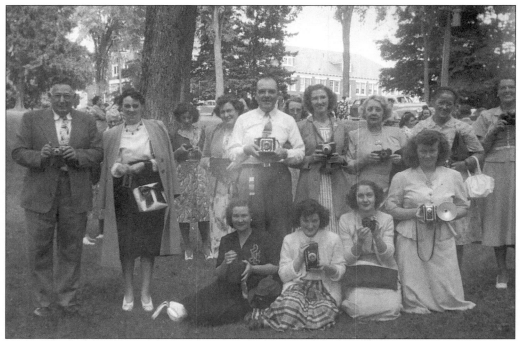

Albert Thomas (center) is shown here with the early camera club. He never tired of taking photographs and his wife, Marjorie, was always his favorite topic. Many of the pictures in this book are from his collection.

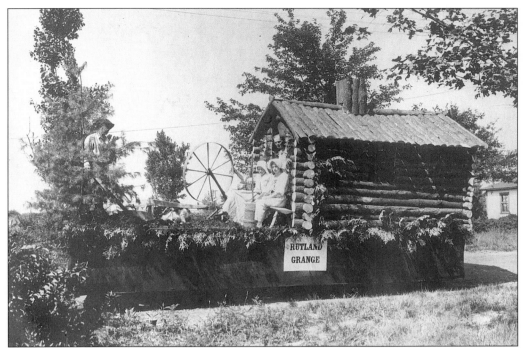

Rutland has had annual parades since its earliest time. Except for a period during WWII, it has been uninterrupted. At the end of the 20th century, the Fourth of July celebration spanned three days. This Rutland Grange entry is from 1930. The Grange was a major social organization in Rutland up through the 1980s, as the town was mostly agrarian then. Albert Thomas wrote the history of the Massachusetts Grange. He and his wife were active in the Grange throughout their lives.

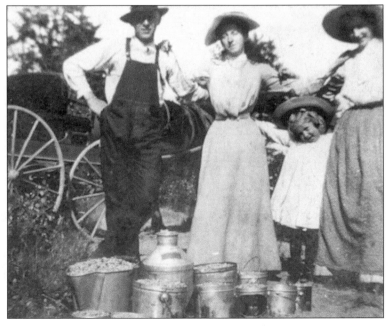

Berry picking was a family affair, as in this 1905 image.

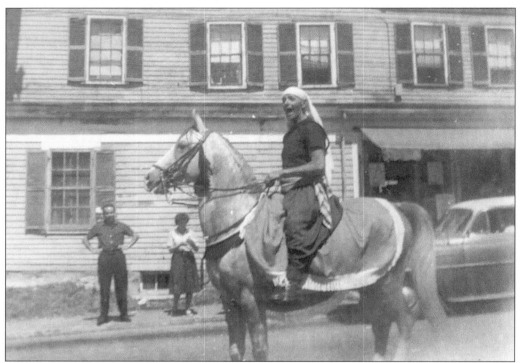

George Phipps was a devoted parade participant on his Arabian steed. In 1959, Tali won first prize for two-year-olds at the Arabian Horse Show of New England in Northampton. The stallion also won second prize in the "produce of a dam" category with his mother, Alzora and sister, Adan.

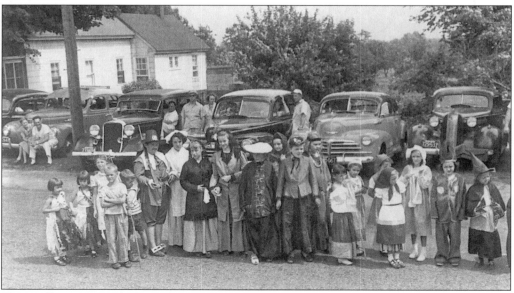

This Halloween parade from the late 1940s was taken in front of the Viner house on Main Street. Cars could easily park off the road at that time. Many of the outfits seen are vintage clothing from their attics.

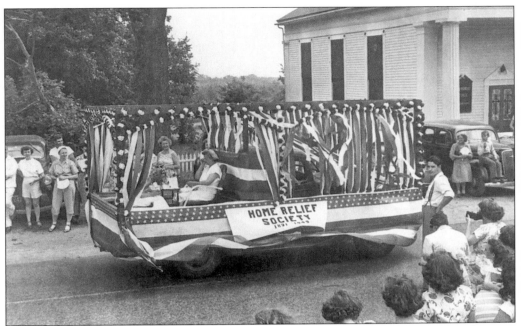

The Home Relief Society float was photographed as it passed the old Catholic church across from the lower Common. This was formally a Methodist church, built in 1844. It was obtained by the Catholic Church in 1881. The Home Relief Society aided families in need.

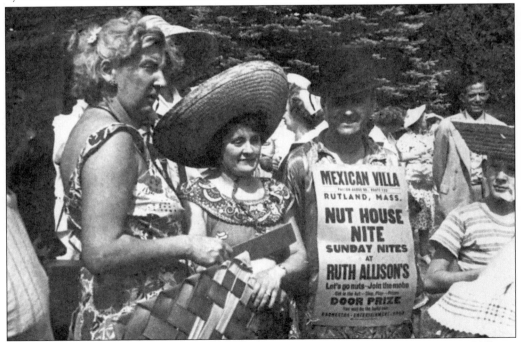

Ruth Allison (left) owned the Mexican Villa on the Barre-Paxton Road. The Mexican Villa on Route 122 was a favorite spot for many of the townspeople, and they readily joined in the town's parade.

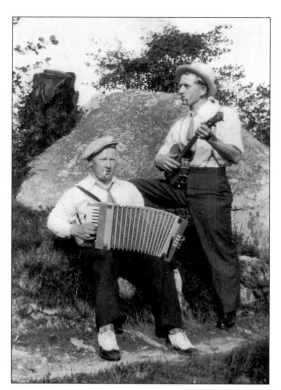

Ralph H. Anderson Sr. (left) and Carl Wahlquist (right) enjoyed their music and spent many summer evenings entertaining at Cool Sandy Beach in the summer.

Bathing has always been popular in Rutland, with its many lakes and beach areas. Marjorie Thomas and Mrs. Demas are ready for a cool swim in this 1920 image.

Fashion shows have been a popular way to raise funds throughout Rutland's history. Here, Bruce Daigneau makes announcements as Bernice Anderson (center) waits to conclude the 1971 "Evolutions in Fashion" show.

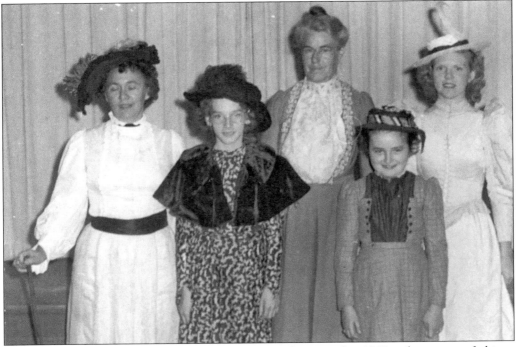

At this Grange "Fashions of the 19th Century" show in the 1940s, these great fashions highlighted the show. Modeling are Hope Bracebridge, Judith Judkins, Amelia Lincoln, Joanne Prescott, and Marion Halcott

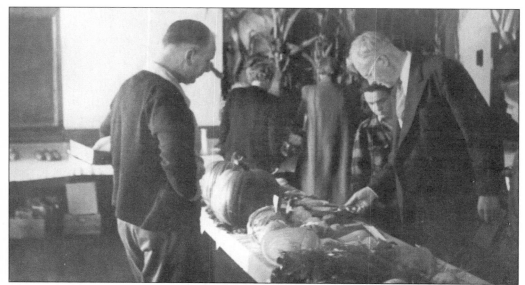

Frank Brooks, longtime selectmen in Rutland, often helped with judging for Grange and school events.

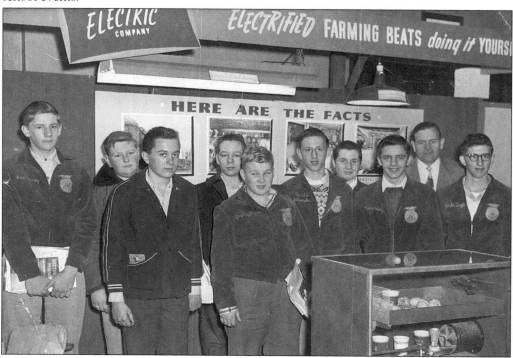

Agriculture was a major occupation in Rutland for most of its earliest history, and some farms survive today. The Future Farmers of America, the Aggi class at the high school, and the Grange were major agrarian training grounds. The Aggi Class of 1955 included, from left to right, the following: (front row) Jim Cunningham, Jay Nystrom, Ronnie Jatowski, Edward Casey, and Clarke Taylor; (back row) Robert Carey, Ralph Anderson Jr., Dave Hammond, Ronnie Jatowski, unidentified, and Carroll Jones.

Doll carriage parades are a major part of the Fourth of July celebration. Marjorie Viner can be seen with her doll carriage in 1949.

A vintage doll gets a topside ride in the doll carriage parade in 1949. An annual road race, a bike parade, and other games are also part of the family celebration, as well as band concerts, chicken barbecues, and strawberry festivals.

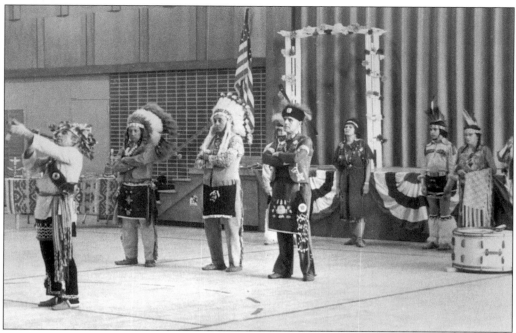

Fred Matthews (in dark regalia) attends a powwow in 1971. Fred, also known as Swift Hawk, was a chief of the Indian Art Lodge of Worcester. He was very active in town recreation and parades and helped with every powwow run for the town celebrations.

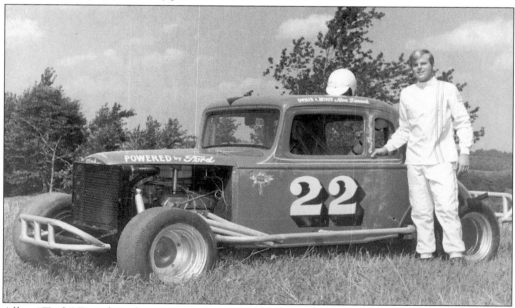

Allen "Tink" Darrah is shown *c.* 1973 with his 1930 Model A Ford Coupe that he used for ice racing. It boasted a 289 engine and all Ford parts, which played a major part in winning 19 first-place trophies in five years. At the time, he had been racing for nine years; that year was the New England ice racing champion. Allen was a member of the Jaffrey Ice Racing Association and also did dirt track racing.

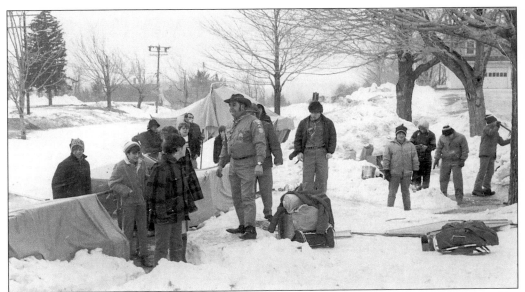

This winter freeze-out camp on the Common was held on the Boy Scouts of America 61st birthday of scouting in 1971. Scoutmaster Francis Brown was in charge and is shown here with the boys.

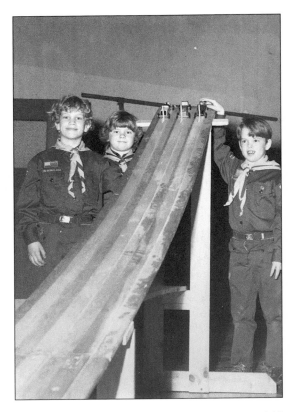

Scouts Jack Mac Callum, John Hyland, and Philip Fougere participated in the first Pinewood Derby in Rutland.

In 1973, Alan Briggs and Dennis Mac Callum broke the adult record of 22.27 minutes in the Annual Doc Thayer 3.8 mile road race. Alan won with a time of 19.30.1 minutes and Dennis followed with a time of 20.03 minutes

Barbara Nichols was the first woman to complete the 3.8-mile race in 1973, then reserved strictly for men. She and two other women, Darlene Anderson and Gerry Mantha, ran the race over the objections of the race committee, knowing they would not be recognized for any trophy.

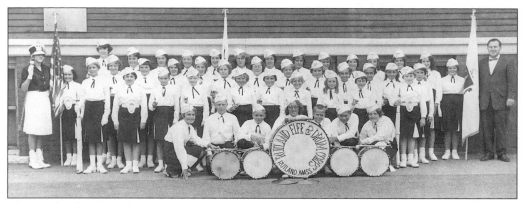

The Rutland Fife and Drum Corp was formed and run by Edmund Butkiewicz, a Rutland teacher, in 1960. By 1963, it boasted 56 members, had won 13 trophies, and had won the 1961 Massachusetts State Championship. It went on to receive many championships and was a favorite for town events until it disbanded in 1977. The 1970 Rutland telephone directory put out by the Rutland Fife and Drum Corp states, "Let us pay tribute to the man, Edmund J Butkiewicz, for his perseverance and tenacity, to mold such a fine group as the Rutland Fife and Drum Corps." In 1972, a smaller version of the first Rutland town flag was presented to the Rutland Fife and Drum Corp after it was adopted by the 250th Anniversary Committee and selectmen. On Founders Day, June 18, 1972, the town flag was raised for the first time. The flag design is a blue town seal with the phrase *Incorporated 1722* under it on a white background.

Members of the Butkiewicz family, from left to right, are as follows: (front row) John, Edmund Sr., and Mary; (back row) Paul and Edmund Jr.

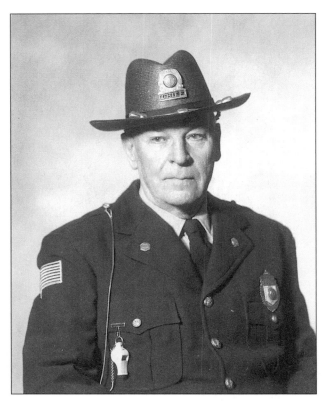

John Collins served Rutland for 35 years from 1935 to 1971 as police chief. He had been a constable since 1921. Collins came to Rutland for his health and, like many others, stayed. He ran a general store until 1966, when he retired. This image was Jack Collins's formal photograph before his retirement as police chief.

Ralph H Anderson Jr. served the town on the police department for 30 years, 15 of them as chief. He served as a fireman before that and was a member of the civil defense team. He also held elected and appointed offices. He has the distinction of being Rutland's first full-time police chief. He retired in 1997.

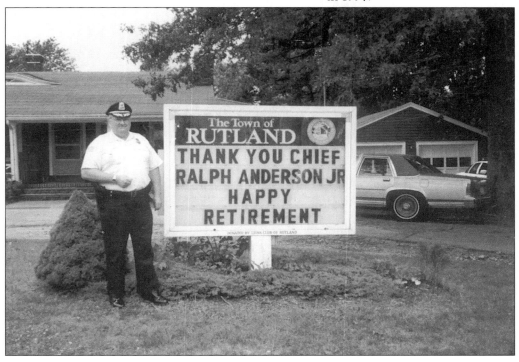

Police chief Ugo Alinovi, here awarding David Kalloch a trophy, still serves the town as a constable. (Photograph by Eugene Kennedy.)

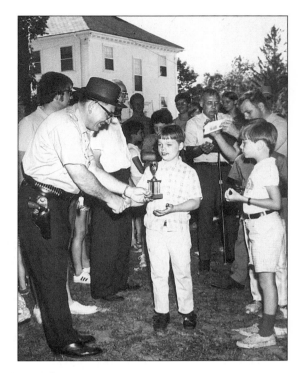

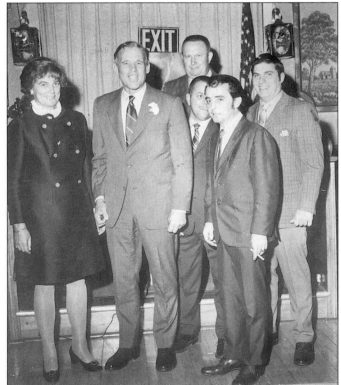

Governor and Mrs. Sargeant (front), at a chance encounter in Barre, graciously posed for this photograph with Russell Gordon, Robert Zoppo, and John Leger (back). Both Russell Gordon and John Leger are former Rutland police chiefs.

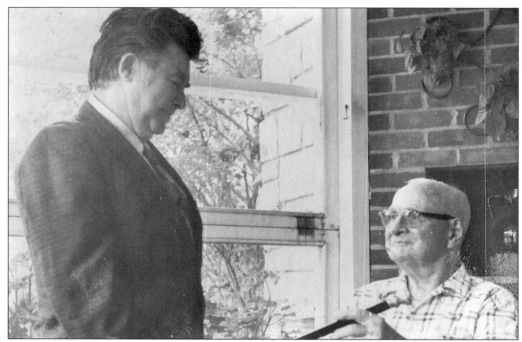

Here, Timothy Murphy receives the Old Boston Post gold-headed cane as Rutland's oldest citizen in 1971 from selectman James Wood. Murphy wrote the *History of Rutland* for the Rutland Historical Society in 1970. He had retired in 1953 and moved to Rutland where he wrote many articles on police work, poetry, and history. He played a prominent part in the organization of the uniformed Massachusetts State Police.

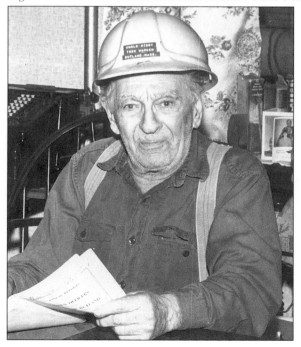

Herbert "Gib" Calkins was Rutland's electrical inspector and dump caretaker. "Uncle Gibby," as he was affectionately called, knew just about everyone and he greeted everyone as they stopped by to dump their trash and visit with each other. He had "first rights" to any pickings and could always be counted on to have just that part you needed. Herbert Calkins retired in 1973. (Photograph by Eugene Kennedy.)

Ed Turner, shown on a patriotic float, was in the 75th Rangers in WWII and served in the same unit from which Merrill's Marauders had come. A movie of Merrill's Marauders was made in 1962 starring Jeff Chandler.

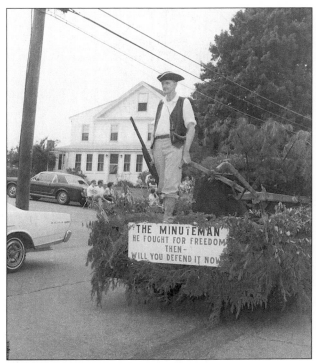

Russell Gordon Jr. takes his duty seriously at Memorial Day services in 1973.

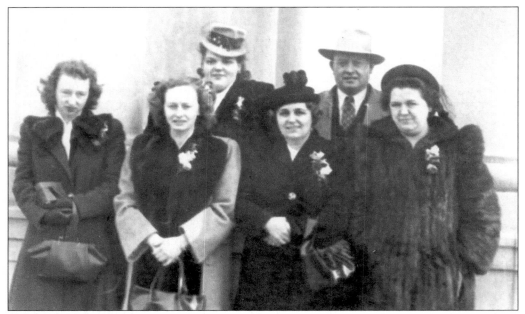

Heading to the city for the day, from left to right, are the following: (front row) Edna Bigelow, Marion Bigelow, Margaret Thomas, and Nora Prescott; (back row) Ethel Luukko and Herbert Bigelow. These folks are ready for shopping, *c.* 1938.

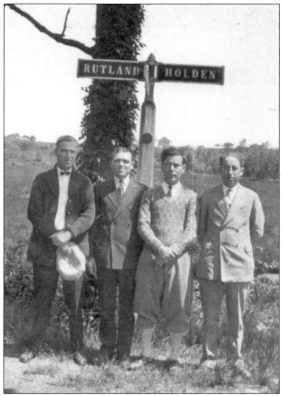

Albert Thomas, second from left, and friends pose at the Rutland and Holden line sign in 1925.

Chairman of the Rutland Board of Selectmen Raymond Becker is shown here in a photograph taken by Eugene Kennedy. He was an important part of the process to get a new water treatment plant in Rutland after years of problems with impurities in the water taken from Muschopauge Pond. Selectman Becker made a motion shortly after it went online to name it the Robert Cannon Water Treatment Facility.

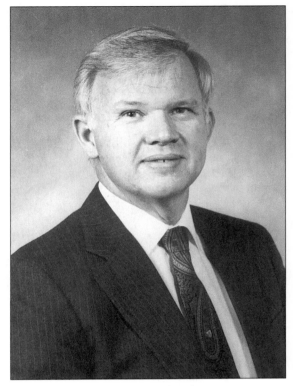

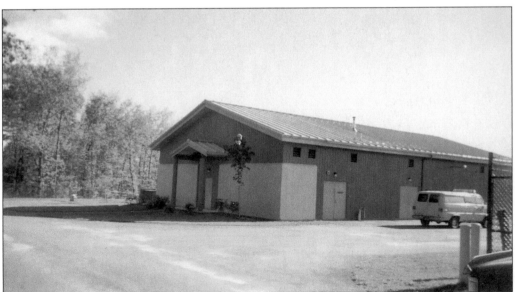

The Robert Cannon Water Treatment Facility is named after the former Water and Sewer Board member who instigated the issue of a new Rutland-owned treatment plant in a 1983 letter to the board. Cannon wrote that Rutland was often forced to use stagnant water, as the town of Holden was drawing more water than the pond's safe yield. The new facility went online in April 1998.

Sandra Fife, Diane Lindquist, Sally Haden, and Patrick Hayden appear in this image.

Acknowledgments

I want to thank Rutland town clerk Sally Hayden for her patience with me and for searching the vault for the documents I sought for this book. I would also like to thank Ruth Temple, Edward Sheridan, fire chief Thomas Ruchala, and Charles Fiske for sharing pictures. Wayne Myers and Eugene Kennedy took many of the photographs in this collection. Throughout the book are photographs taken by Albert Thomas. I also want to thank Arcadia Publishing for their endless patience with me.

Last, but by no means least, I thank my sister, Jeene Collins, for her endless help in putting this book together. Without her help, I would still be searching for pictures and words.

Somewhere between work, grandchildren, and meetings, this volume is finished to share with you. I look forward to future publications—later.